LIFE IN THE COUNTRY

That Patchwork Place

with COUNTRY THREADS

Mary Tendall and Connie Tesene

Credits

Editor-in-Chief	Kerry I. Smith
Technical Editor	Ursula Reikes
Managing Editor	Judy Petry
Design Director	Cheryl Stevenson
Text and Cover Designer	Amy Shayne
Production Assistant	Claudia L'Heureux
Copy Editor	Liz McGehee
Proofreader	Leslie Phillips
Illustrator	Robin Strobel
Illustration Assistant	Mary Ellen Buteau
Photographer	Brent Kane
Decorative Art	Barb Tourtillotte

Acknowledgments

Thank you to:

Our shop and office manager, Mary Baker, and the entire staff at Country Threads;

Our families and close friends, for their patience;

Ursula, for her love of animals and all her help on this book;

And a big thanks to That Patchwork Place, for the opportunity to once again be part of its publishing family.

MISSION STATEMENT

WE ARE DEDICATED TO PROVIDING QUALITY PRODUCTS AND SERVICE BY WORKING TOGETHER TO INSPIRE CREATIVITY AND TO ENRICH THE LIVES WE TOUCH.

Life in the Country with Country Threads
© 1997 by Mary Tendall and Connie Tesene
That Patchwork Place, Inc., PO Box 118
Bothell, WA 98041-0118 USA

Printed in Hong Kong
02 01 00 99 98 97 6 5 4 3

Library of Congress Cataloging-in Publication Data

Tendall, Mary,
 Life in the country with Country Threads / Mary Tendall and Connie Tesene.
 p. cm.
 ISBN 1-56477-185-7
 1. Patchwork—Patterns. 2. Quilting—Patterns.
3. Animals in art. I. Tesene, Connie, . II. Title.
TT835.T37 1997
746.46—dc21 97-1048
 CIP

TABLE OF CONTENTS

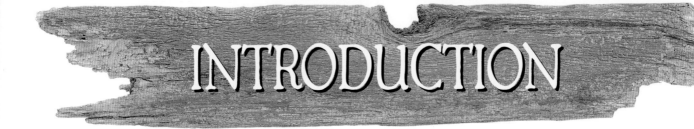

Life in the Country represents for me a lifelong love of animals. Growing up in the '50s as a farmer's daughter, I learned how to take care of all kinds of animals.

In 1983, when Connie and I started Country Threads, my sister-in-law gave me a Banty hen and a rooster with a family of chicks. An uncle bought me four sheep to help keep the weeds and grass mowed around the barn. I also had one precious cat named Morris and a stray yellow Lab puppy named Sally.

Sally lived thirteen years on the farm. When we lost her, I vowed never to get another dog because of the devastation of losing such a beloved pet. When a golden retriever named Red found me three years later, I crumpled once again under the compassion I felt for a truly wonderful dog who needed a loving, secure home. Then I decided Red needed a playmate to keep her active and healthy. Red and I found Sandy, a three-year-old wirehaired terrier mix, at the local shelter. Sandy likes to show everybody who visits that she is in charge of the parking lot. She and Red are my constant companions.

Country Threads has always been partial to chickens. Our very first book, *On Behalf of Chickens,* is now out of print, but we still get many requests for it. We introduced it years before the Country trend included chickens, and consequently it was never a big seller, so we dropped it.

During the spring and summer months, I gather one to two dozen eggs every day. Since I don't cook much and wouldn't dare bake anything for fear of eating it all, I give them to our staff, neighbors, friends, family, and customers who appreciate farm-fresh eggs.

I had ducks years ago, but found them to be quite fragile and easy prey for many predators that live in the area. My first twelve ducks were barter from a neighbor whose daughter was taking piano lessons from me. I raised many ducklings from those original twelve, but today the only duck on the place is an old Muscovy called David's Duck. I had tried on many occasions to capture this elusive duck, but finally Mary Baker's son David did the job. It was in the middle of the busiest day of the whole year at Country Threads. Donna, our van-shuttle driver bringing a full load of customers from town, happened to mention seeing a duck along the road. I sent David in my old pickup, armed with a landing net, to capture the duck. He came back with a very rough-looking old duck. With a steady meal ticket and a good bath, David's Duck became a proud member of the local flock.

David's Duck shares the pond with fourteen very vocal geese who like to intimidate customers who come too close to the fence. The geese were unsuccessful hatching goslings their first year, mostly due to raccoon raids during the night. Losing poultry of all kinds to raccoons, foxes, skunks, owls, opossums, and even coyotes is my biggest problem during the summer months. I have learned to shoot a rifle when I absolutely have to, to protect my pets. I also have a live animal trap. Sympathetic friends Don Pedersen, Tony Urich, and Tom Rose all lend a hand when it comes to disposing of the trapped animals.

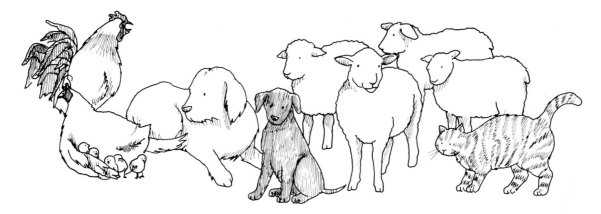

Ending up alone on the farm, I found I could not handle the sheep. They became too crippled and too hard to shear, so I started collecting pygmy goats. These goats are much more fragile to raise than anyone might think, but they are my favorite farm animals. Each one has a distinct personality and is very sociable. The goats love people and are always willing to come to the fence to eat a leaf from a child's hand. Louise, Luther, Zelda, Zuby, and Zoe are firmly ensconced as leaders in the barnyard.

My personal view of "life in the country" cannot be easily measured or explained. Sitting on the front porch on a summer evening, listening to all the night noises and inhaling the smell of tasseling corn; reaching into a hen's nest on a frigid winter morning and bringing out a warm brown egg; walking with the dogs through the newly combined cornfield on a warm October day and hauling home ears of corn in a pail for the squirrels to eat during the winter; and waking up at dawn during the month of May to the smell of green grass and the call of a pair of resident mourning doves … these are some of my favorite days in the country.

Our customers enjoy the country life when they visit Country Threads. Whether strolling through the haymow decorated with quilts, watching the goats and geese wander through the pasture, sitting in the lawn chairs under the maple tree, or enjoying the quilt shop, they delight in the down-home lifestyle we live every day. Certainly not just any business can survive in rural America, but over the years, we have formed our business around country life. When the roads are closed due to snow, the quilt shop is closed. When school is delayed until 10 a.m., the quilt shop doesn't open until 10 a.m. either. When we are needed to herd the goats into their pen, we simply take the phone off the hook and herd the goats. And when planting season and

harvesttime rolls around, we all know several staff members will need time off to work in the fields with their husbands.

Whenever I want to leave the farm for a vacation or for Quilt Market, I hire a pet sitter to take care of the house pets as well as the livestock. The sitter also oversees the parking lot, the yard, the quilt shop, the classroom, and any potential problems that may arise. Bob and Donna Pearson, a retired couple from Fort Dodge, Iowa, and Chris Christie, a kindergarten teacher from Mankato, Minnesota, are my mainstays. Without them, I would find it impossible to take even short trips. They are extremely valuable to both Country Threads and me, and are an important aspect of running a business in the country as a single woman.

When Connie and I were introduced in 1981 by a mutual friend, we discovered we both loved folkart, quilts, antiques, food, and pets. With her sense of original design and color and my location in the country, we soon discovered a potential business endeavor.

Country Threads, which started with a $300 investment from each of us, now publishes quilt patterns and books as well as a newsletter. We offer machine-quilting services, a retail mail-order business, a retreat in the barn for quilters, and a bed-and-breakfast dormitory. Country Threads is a destination for quilters from around the world as well as from our own backyard. In 1995, it was selected as one of America's top-ten quilt shops.

What does the future hold? Both Connie and I hope for more free time to sew more quilts. I personally never want to move from here. My life in the country includes a successful home business that allows me to watch over my animals all day long while I'm at work. I feel that I have the best of both worlds.

—Mary Beth Tendall

GENERAL DIRECTIONS

The Country Threads Look

To achieve our Country Threads look, we use a wide variety of fabrics in many different shades and tints of a particular color. Look carefully at the photos of the quilts. You'll probably be amazed at just how many different fabrics are used. For example, take a look at the reds within any one quilt. You'll see that the assortment includes rose, burgundy, true red, red-orange, maroon, and sometimes a dash of pink. We also use a variety of light backgrounds in our quilts, including ivory, off-white, tan, brown, gray, taupe, and everything in between.

We are especially fond of plaids and checks, and we cut these fabrics without paying attention to the grain line. This adds to the old-time appearance we like in our quilts. However, if you prefer not to have plaids and stripes that "wiggle" across your quilt, then cut your fabrics on the straight grain.

Yardage requirements are provided for each quilt, and most call for an assortment of fabrics. When using lots of bits and pieces, it is difficult to estimate the exact amount needed. Larger pieces of fabric are indicated when needed. When you see an amount given as "1 yd. total of assorted fabrics," it means a combination of scraps, ⅛-yard pieces, fat quarters, and leftovers from other projects to total one yard. Remember, when working with scraps, don't worry about running out of a fabric, because no particular fabric was meant to be matched in the first place.

Overdyeing Fabric

We often resort to overdyeing with tan dye when we aren't happy with a fabric in our collection. This adds a warm, mellow look to almost any fabric. Never, however, dye a complete quilt; otherwise, the lights won't sparkle.

Place three yards of like-colored fabric in your washing machine. Set the water level to the lowest setting and double the amount of dye called for in the manufacturer's directions. This ensures a dark look, especially on dark-colored fabric. Reduce the amount of dye to achieve lighter shades. We use Rit® tan dye.

Making Templates

Piecing Templates

All piecing templates include ¼"-wide seam allowances. Make templates from plastic or cardboard. Trace around the edges on the right side of the fabric and cut on the drawn line.

Appliqué Templates

We combine both hand appliqué and fusible appliqué in most of our quilts. Hand appliqué is reserved for those pieces that are large enough to be stitched comfortably. For smaller pieces and letters, we prefer to use the fusible-appliqué method and then buttonhole-stitch the edges on the sewing machine. Choose whichever method you prefer. Appliqué templates *do not* include seam allowances.

The appliqué templates are right side up for use in traditional appliqué, except for the letters, which are reversed for use with fusible appliqué. If you want to use the fusible method for templates other than letters, you may want to reverse the patterns before tracing them onto paper-backed fusible web; otherwise, the designs will be reversed when you are finished. In most cases, reversing a design is of little consequence; for example, critters can face either left or right. So be aware of the direction of the templates and make adjustments according to the method you are using.

For traditional appliqué, make templates for all pieces that will be appliquéd. If the pattern is one you plan to use often, make templates from plastic

or cardboard. For one-time use, we like to use freezer paper. Trace the patterns onto the material of your choice and cut them out on the drawn line. Remember, you don't need to reverse the patterns with this method.

With plastic or cardboard templates, trace around the edges on the right side of the fabric and cut ⅛" to ¼" beyond the drawn line. Turn under the raw edges along the drawn line and hand baste or press. Appliqué in place.

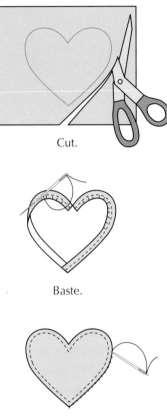

Cut.

Baste.

Slipstitch.

If you are using freezer-paper templates, iron the templates to the right side of the fabric. Trace around the edges of the freezer paper and cut ⅛" to ¼" beyond the drawn line. Turn under the raw edges along the drawn line and hand baste or press. Appliqué in place.

For fusible appliqué, trace the pattern onto the paper side of paper-backed fusible web. Remember to reverse the patterns before tracing, if necessary. Cut out the appliqué just beyond the drawn line. Iron the appliqué to the wrong side of the fabric and cut on the drawn line. Remove the paper backing,

position the appliqué on the background, and press in place. Use a buttonhole stitch around the edges to secure the appliqué. You can do this by hand or on your sewing machine. Match the thread color to the appliqué fabric whenever possible.

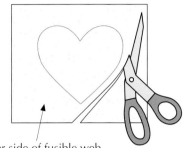

Paper side of fusible web

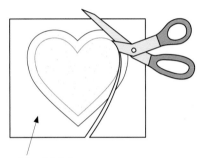

Wrong side of fabric

Buttonhole stitch

Adding Connector Squares

We thank Mary Ellen Hopkins for this easy method of adding a triangle corner to background squares and rectangles. It works especially well when the desired finished triangle is very small. *The letter "c" following a number is used to designate a connector square.*

1. With right sides together, place the connector square on the designated background piece in the appropriate corner. Stitch diagonally from corner

to corner across the square as shown in the piecing diagram for the block you are making.

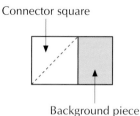

2. Trim the outside corner of the connector square. (Do not trim the corner of the background piece.) Press the triangle toward the corner.

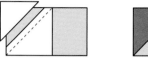

Trim outer corner
of connector square only.

Cutting Half-Square and Quarter-Square Triangles

To achieve a scrappy look, we often cut more triangles than we need and then save the leftovers for other projects. For example, if we need four quarter-square triangles for a block, we could cut one square twice diagonally. However, if we used the resulting four triangles in our block, they would all be from the same fabric. Since we are aiming for a scrappy look, we usually cut four squares and only use one triangle from each square. This is also true for half-square triangles.

Half-Square
Triangles

Quarter-Square
Triangles

Note: The symbols ◲ and ◳ are used to designate when to make half-square and quarter-square triangles.

Assembling the Quilt Top

When all the blocks for a quilt are completed, sew them together. Refer to the quilt plan and photo for guidance. In general, blocks are sewn together into small sections first, then the small sections are joined to complete the quilt top. For some quilts, you will need to cut additional spacer pieces to complete the top. The dimensions for these are indicated in the directions.

Adding Borders and Binding

All borders are cut across the width of the fabric. Add the top and bottom borders first, then add the side borders, pressing the seams toward the borders.

Binding is cut 1½" wide across the width of the fabric. Join strips as necessary to go around the perimeter of the quilt, plus a little extra for the corners. Attach the binding through all three layers of the quilt before trimming any excess batting and backing.

Quilting

There just aren't enough hours in the day to hand quilt like we used to. The larger quilts are machine quilted by staff members with a 100% low-loft cotton batting. Our smaller quilts are hand quilted with a low-loft, dense fleece instead of batting so the quilts stay flat when hung on a wall. The majority of our quilts are quilted in a meandering stipple pattern, using a neutral thread.

THE QUILTS

The quilt designs in this book are representative of our style. They contain a combination of pieced blocks and primitive appliqué. You can make the quilts as directed, or use only parts of them to make your own quilt design. For example, if you don't want to tackle the entire "Rabbit Hollow" quilt (page 78), combine one or two of the Rabbit blocks with one of the Tulip blocks to make a smaller quilt. Sketch your ideas on graph paper before beginning.

Remember, however, our block designs are copyrighted and are for your personal use only. They cannot be published or reprinted in any form.

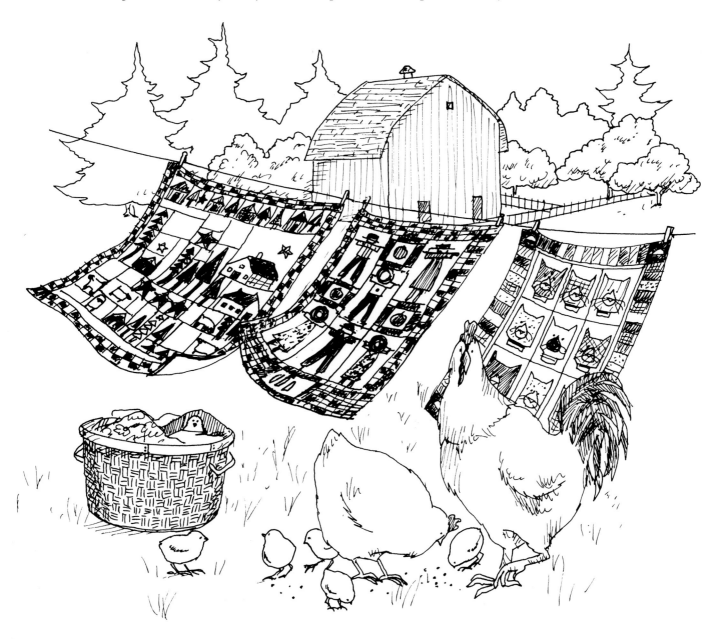

Chickens on Parade

Quilt Size: 14½" x 48½"

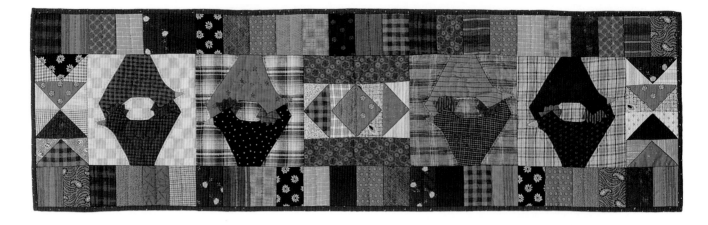

CHICKENS are a part of everyday life at Country Threads. They wander freely around the yard and roost in the barn at night. The roosters' cock-a-doodle-doos can be heard throughout the business day. Baby chicks arrive at the post office in the spring from the hatchery in Webster City, Iowa. They are from a fancy breed assortment, so we don't know what kind they are until they grow up.

Kindergarten chickens arrive nearly every May from a friend who teaches kindergarten. She incubates the eggs in her classroom. When the chicks are two weeks old, they need a bigger home so she brings them to Country Threads. Visitors, old and young alike, are entertained by hens, roosters, and baby chicks during the spring, summer, and fall months. During the winter, the barn is equipped with heat lamps and a propane heater to keep the chickens comfortable.

<h1 style="text-align:center">Materials: 44"-wide fabric</h1>

<div style="text-align:center">

1 yd. total of assorted golds
1 yd. total of assorted blues
½ yd. total of assorted reds
¼ yd. total of assorted lights
1½ yds. for backing
¼ yd. for binding
Batting

</div>

Directions

All measurements include ¼"-wide seam allowances. Use the templates on page 12. Refer to the individual block diagrams for positioning the appliqué pieces.

Chicken Block

From the assorted blues and golds, cut 4 squares, each 8½" x 8½". Cut out and appliqué 2 chickens (pieces #1–#3) to each square.

Chicken Block
Make 4.
Finished Size: 8" x 8"

Flying-Geese Units

1. Cut and piece 12 units. Cutting instructions are for 12 units.

Piece	Fabric	No. of Pieces	Dimensions
#1	Assorted	3	5¼" x 5¼" ⊠
#2	Background	12	2⅞" x 2⅞" ◻
#3	Blues	2	2½" x 8½"

Flying-Geese Unit
Make 12.
Finished Size: 4" x 2"

2. Sew the flying-geese units together as shown. Add 1 blue rectangle #3 to each side of the center block.

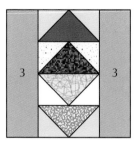

Flying Geese Center Block
Make 1.
Finished Size: 8" x 8"

Flying Geese Side Block
Make 2.
Finished Size: 4" x 8"

Pieced Borders

From the assorted fabrics, cut 48 rectangles, each 2½" x 3½". Join 24 rectangles each to make the top and bottom borders.

Make 2.

Assembly and Finishing

1. Referring to the quilt plan on page 12 and the color photo on page 10, sew the blocks and borders together.
2. Layer the quilt top with batting and backing; baste. Quilt as desired and bind the edges.

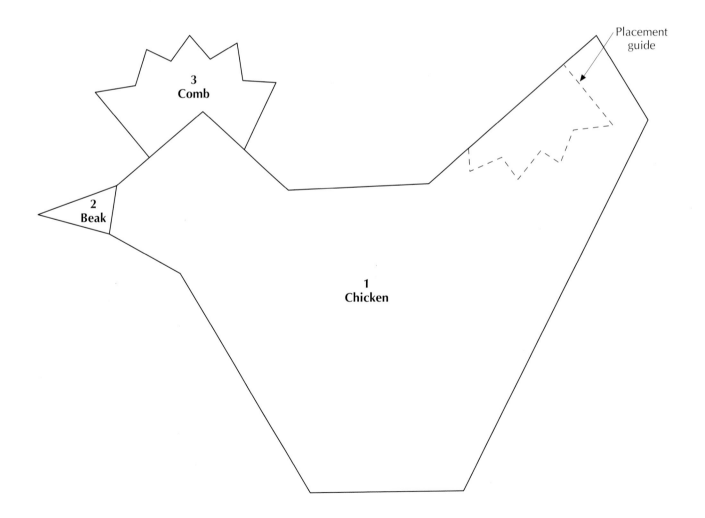

Quilt Plan

3
Comb

Placement
guide

2
Beak

1
Chicken

Floral Linen Hearts

Quilt Size: 61½" x 79½"

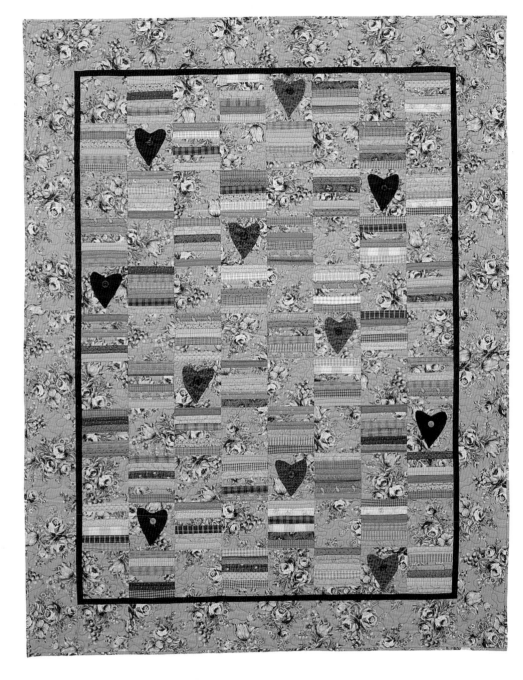

SOMETIMES we like to sew something simple—just for the pure enjoyment of combining fabrics and colors. This quilt was an exercise in relaxation because we let the fabric do all the work. The green and mauve floral linen doesn't look like a Country Threads choice, but we wanted to see if we could take a different fabric and make it look like a Country Threads quilt. Exploring different colors is easier when we don't have to think about the quilt design. This was such a simple project, but because the floral linen is so busy, it looks more difficult. We worked on this quilt on a rainy Sunday afternoon last summer—can you think of anything more inviting?

Materials: 44"-wide fabric

3¼ yds. floral print for blocks, outer border, and binding
2 yds. total of assorted fabrics to coordinate with floral print
¼ yd. total of assorted reds for hearts
⅓ yd. for inner border
4¾ yds. for backing
Batting
11 buttons for hearts

Directions

All measurements include ¼"-wide seam allowances. Use the template below. Refer to the individual block diagrams for positioning the appliqué pieces.

Floral Square Blocks

From the floral print, cut 44 squares, each 6½" x 6½". Appliqué a heart in the middle of 11 squares. (Add more hearts to your quilt if desired.)

Floral Square Block
Make 11.
Finished Size: 6" x 6"

Scrappy Square Blocks

From the assorted fabrics, cut 264 rectangles, each 1½" x 6½". Join 6 strips to make a 6½" x 6½" square, including seam allowances. Select strips randomly for a scrappy look. Make 44 scrappy squares.

Scrappy Square Block
Make 44.
Finished Size: 6" x 6"

Note: To speed-piece the Scrappy Square blocks, cut 1½"-wide strips from assorted fabrics, then join 6 strips to make a strip unit. Cut 6½" squares from the strip unit. You will not get as much variety in your blocks using this method.

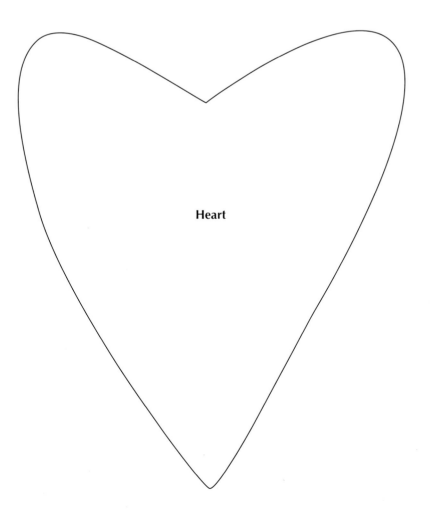

Heart

Assembly and Finishing

1. Arrange the blocks into 11 rows of 8 blocks each, alternating the Floral Square and Scrappy Square blocks. Place the blocks with hearts as desired. Sew the blocks into rows. Join the rows.

2. From the inner border fabric, cut 6 strips, each 1¼" x 42". Join the strips end to end to make one continuous strip. Cut 2 strips, each 1¼" x 48½", for the top and bottom borders, and 2 strips, each 1¼" x 68", for the sides. Sew the top and bottom inner borders to the quilt top first, then add the side borders.

3. From the floral print, cut 7 strips, each 6¼" x 42", for the outer border. Join the strips end to end to make one continuous strip. Cut 2 strips, each 6¼" x 50", for the top and bottom borders, and 2 strips, each 6¼" x 79½", for the sides. Sew the top and bottom outer borders to the quilt top first, then add the side borders.

4. Layer the quilt top with batting and backing; baste. Quilt as desired and bind the edges. Add a button to each heart.

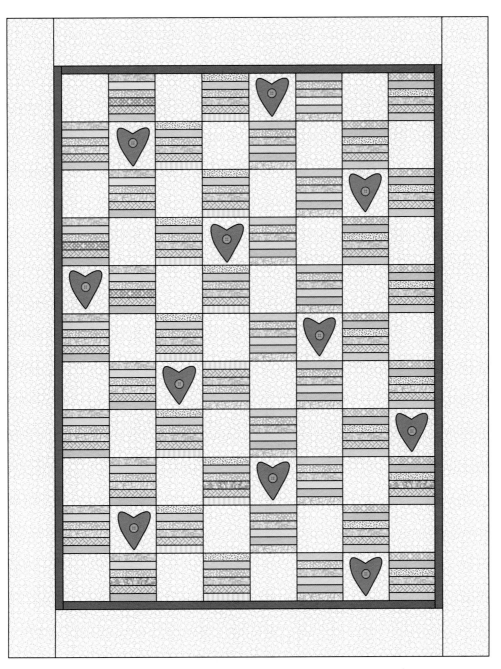

Quilt Plan

Cat Fancy

Quilt Size: 40½" x 52½"

At the time this quilt was made, there were fourteen cats at Country Threads, but not all of them could be included. Several of the cats were calicoes, and it was hard to find fabric to match their color and pattern. They kept turning out "spotted" and didn't look quite right. A totally black cat was also difficult because you couldn't see the features, so Snag was left out too.

Bob was the other cat that was left out because we didn't want to alter the pattern for him. His ears tip down as if he were part Scottish fold. When Bob came to Country Threads, he was injured and weighed only nine pounds. Today, he steps up to the scale at a hefty sixteen pounds.

We never have to go looking for cats, because, in time, they all show up here looking for a good home—and they get one.

Materials: 44"-wide fabric

¼ yd. of 9 different fabrics for backgrounds
¼ yd. of 9 different fabrics for cat heads
Scraps of 9 contrasting fabrics for cat faces
Assorted scraps for cat collars, noses, and eyes
¾ yd. total of assorted fabrics for pieced borders
4 squares of assorted dark fabrics, each 4½" x 4½", for corner squares
¼ yd. for inner border
1⅝ yds. for backing
¼ yd. for binding
Batting
Embroidery floss in black, white, and gray
Optional: permanent marker

Directions

All measurements include ¼"-wide seam allowances. Refer to pages 7–8 for sewing connector squares "c." Use the templates on page 19. Refer to the individual block diagrams for positioning the appliqué pieces.

Cat Block

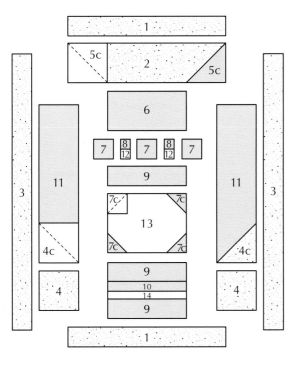

1. Cut and piece 9 blocks, using pieces #1–#14. Cutting directions are for 1 block.

Piece	Fabric	No. of Pieces	Dimensions
#1	Background	2	1½" x 8½"
#2	Background	1	2½" x 8½"
#3	Background	2	1½" x 14½"
#4	Background	4	2½" x 2½"
#5	Head	2	2½" x 2½"
#6	Head	1	2½" x 4½"
#7	Head	7	1½" x 1½"
#8	Head	2	1" x 1"
#9	Head	3	1½" x 4½"
#10	Head	1	1" x 4½"
#11	Head	2	2½" x 8½"
#12	Eye	2	1" x 1"
#13	Face	1	3½" x 4½"
#14	Collar	1	1" x 4½"
#15	Pupil	1	Template #15
#16	Face (to match #13)	1	Template #16
#17	Nose	1	Template #17

2. Cut out the face, nose, and pupil pieces. Join the face (piece #16) and nose (piece #17); treat as one piece. Appliqué in place. Appliqué the pupils (piece #15). Embroider the whiskers, mouth, and name on the collar.

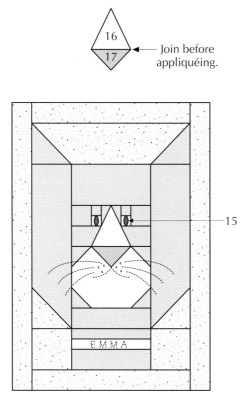

Cat Block
Make 9.
Finished Size: 10" x 14"

Mouse Corner Squares

Cut out mouse pieces (pieces #18 and #19). Appliqué a mouse to each 4½" corner square. Embroider a tail. Draw the eye with a permanent marker or add a French knot.

Mouse Corner Square
Make 2 and 2 reversed.
Finished Size: 4" x 4"

Pieced Borders

From the assorted fabrics, cut 76 rectangles, each 2½" x 4½". Join 22 rectangles each to make 2 side borders, and 16 rectangles each to make the top and bottom borders. Add 1 mouse corner square to each end of the top and bottom borders.

Side Borders
Make 2.

Top and Bottom Borders
Make 2.

Assembly and Finishing

1. Sew the Cat blocks together in 3 rows of 3 blocks each. Join the rows.
2. From the fabric for the inner border, cut 2 strips, each 1½" x 30½", for the top and bottom borders, and 2 strips, each 1½" x 44½", for the sides. Join strips as necessary to achieve the required length. Sew the top and bottom inner borders to the quilt top first, then add the side borders.
3. Sew the side pieced borders to the quilt top, then add the top and bottom borders.
4. Layer the quilt top with batting and backing; baste. Quilt as desired and bind the edges.

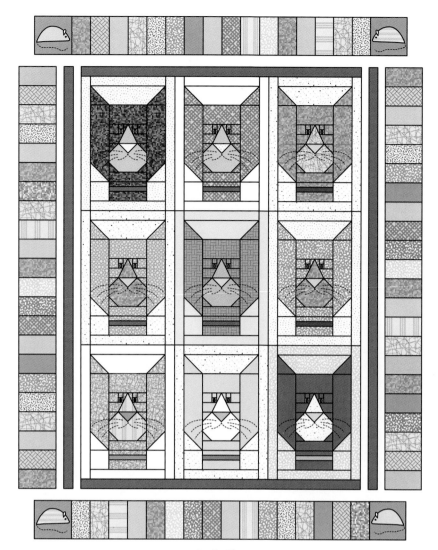

Quilt Plan

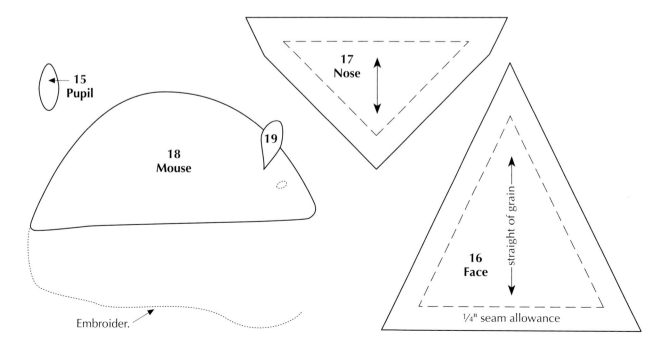

15
Pupil

17
Nose

18
Mouse

19

16
Face

straight of grain

¼" seam allowance

Embroider.

Scarecrows

Quilt Size: 22½" x 35½"

SCARECROWS, so typical in Grandmother's garden, are making a comeback today. "Yard art" is featured in Country magazines across America. Our tribute to the scarecrow is machine pieced with just a touch of appliqué for fun. Easy, fast, and scrappy … our best just for you.

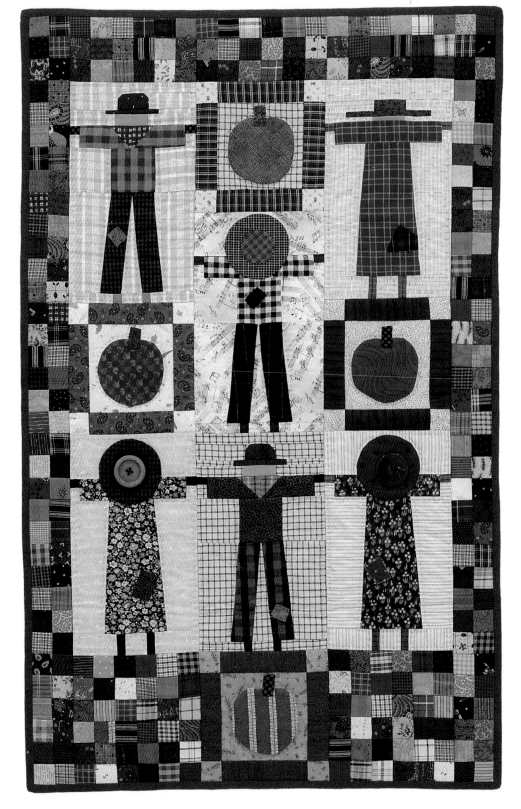

Materials: 44"-wide fabric

⅛ yd. each of 10 light background fabrics
½ yd. total of assorted reds, blues, golds, browns, oranges, and greens
¾ yd. for backing
¼ yd. for binding
Batting
2 large buttons for Girl Scarecrow hats

Directions

All measurements include ¼"-wide seam allowances. The "r" next to a number means you flip the piece over and cut that number of reverse pieces. Refer to pages 7–8 for sewing connector squares "c." Use the templates on the pullout pattern. Refer to the individual block diagrams for positioning the appliqué pieces.

Boy Scarecrow Blocks

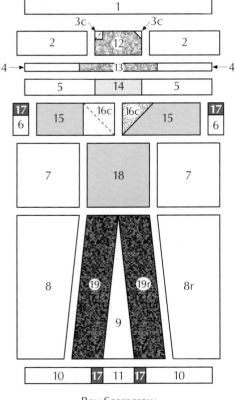

Boy Scarecrow
Make 2.
Finished Size: 6" x 10"

1. Cut and piece 2 blocks, using pieces #1–#19. Cutting directions are for 1 block. Cut a patch freehand and baste to the pants or shirt.

Piece	Fabric	No. of Pieces	Dimensions
#1	Background	1	1" x 6½"
#2	Background	2	1¼" x 2¾"
#3	Background	2	¾" x ¾"
#4	Background	2	¾" x 2¼"
#5	Background	2	1" x 2¾"
#6	Background	2	1" x 1⅛"
#7	Background	2	2½" x 2½"
#8	Background	1 and 1r	Template #8
#9	Background	1	Template #9
#10	Background	2	1" x 2⅝"
#11	Background	1	1" x 1½"
#12	Hat	1	1¼" x 2"
#13	Hat	1	¾" x 3"
#14	Face	1	1" x 2"
#15	Shirt	2	1½" x 3"
#16	Bandanna	2	1½" x 1½"
#17	Dark	4	⅞" x 1"
#18	Shirt	1	2½" x 2½"
#19	Pants	1 and 1r	Template #19

2. Cut and piece 1 Boy Scarecrow block with hat top, substituting pieces #20 and #21 for pieces #1–#5 and #12–#16. Appliqué the hat (pieces

#22 and #23). Cut a patch freehand and baste to the pants or shirt.

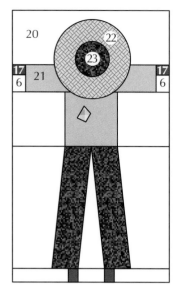

Boy Scarecrow with Hat Top
Make 1.
Finished Size: 6" x 10"

Piece	Fabric	No. of Pieces	Dimensions
#20	Background	1	2½" x 6½"
#21	Shirt	1	1½" x 5½"

Girl Scarecrow Blocks

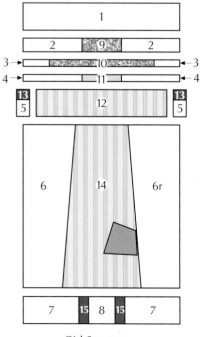

Girl Scarecrow
Make 1.
Finished Size: 6" x 10"

1. Cut and piece 1 block, using pieces #1–#15. Cutting directions are for 1 block. Cut a patch freehand and baste to the dress.

Piece	Fabric	No. of Pieces	Dimensions
#1	Background	1	1½" x 6½"
#2	Background	2	1" x 2¾"
#3	Background	2	¾" x 1½"
#4	Background	2	¾" x 2¾"
#5	Background	2	1" x 1⅛"
#6	Background	1 and 1r	Template #6
#7	Background	2	1½" x 2⅝"
#8	Background	1	1½" x 1½"
#9	Hat	1	1" x 2"
#10	Hat	1	¾" x 4½"
#11	Face	1	¾" x 2"
#12	Dress	1	1½" x 5½"
#13	Dark	2	⅞" x 1"
#14	Dress	1	Template #14
#15	Dark	2	⅞" x 1½"

2. Cut and piece 2 Girl Scarecrow blocks with hat top, substituting piece #16 for pieces #1–#4 and #9–#11. Appliqué the hat brim (piece #22). Use a large button for the hat crown. Cut a patch freehand and baste to the dress.

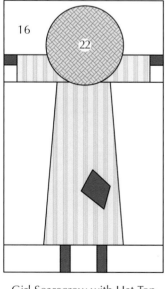

Girl Scarecrow with Hat Top
Make 2.
Finished Size: 6" x 10"

Piece	Fabric	No. of Pieces	Dimensions
#16	Background	1	2½" x 6½"

Pumpkin Blocks

Cut and piece 4 blocks, using pieces #1–#3. Cutting directions are for 1 block. Appliqué pieces #4 and #5.

Piece	Fabric	No. of Pieces	Dimensions
#1	Background	1	4½" x 4½"
#2	Background	4	1½" x 1½"
#3	Blue	4	1½" x 4½"
#4	Pumpkin	1	Template #4
#5	Stem	1	Template #5

Pumpkin Block
Make 4.
Finished Size: 6" x 6"

36-Patch Blocks

From the assorted scraps, cut 72 squares, each 1½" x 1½". Sew the squares into 6 rows of 6 blocks each. Join the rows.

36-Patch Block
Make 2.
Finished Size: 6" x 6"

Pieced Borders

From the assorted scraps, cut 194 squares, each 1½" x 1½". Join 54 squares into 3 rows of 18 squares each to make the top border. Join 70 squares into 2 rows of 35 each to make 1 side border. Make 2 side borders.

Top Border
Make 1.

Side Border
Make 2.

Assembly and Finishing

1. Referring to the quilt plan below and the color photo on page 20, sew the blocks together.
2. Sew the pieced top border to the quilt top first, then add the side borders.
3. Layer the quilt top with batting and backing; baste. Quilt as desired and bind the edges.

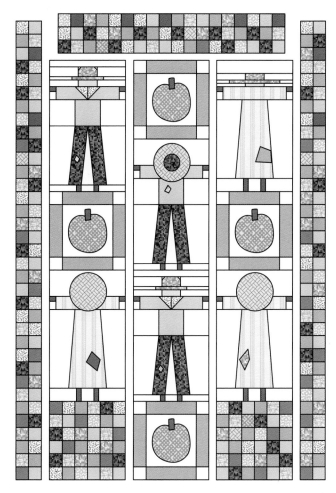

Quilt Plan

Spools and Pets

Quilt Size: 30½" x 47½"

THIS QUILT is inspired, of course, by some of the critters that live at Country Threads. Gert, the goose, is a member of the Great Goose Group. She arrived at the post office along with the others when they were one day old. The "gosling whistle" could be heard from inside the building as I pulled up at 7 a.m. to bring them home.

Louise, the pygmy goat, was my first goat. I got her six years ago from my neighbor, Louise.

Jess, the Doberman/Lab mix, is Connie's dog. She runs three miles every morning with Connie's husband, Roy. Jess came to the Tesene home from the Humane Society—she got lucky.

Emma, the orange tabby who lives in the quilt shop, is twelve years old and was born during the 1984 Summer Olympics. I remember watching Mary Lou Retton vault to a perfect score of ten while watching over Emma and her three brothers and sisters, less than twenty-four-hours old.

Betty, the hen, is actually many hens—I call a lot of them Betty. My current Betty hen hatched ten chicks in the spring and is now sitting on her second clutch of eggs.

Red, my beloved golden retriever, came to me from a neighbor who kept her tied in the barn all the time. She also got lucky.

It's easy to see what we like best—quilts and animals.

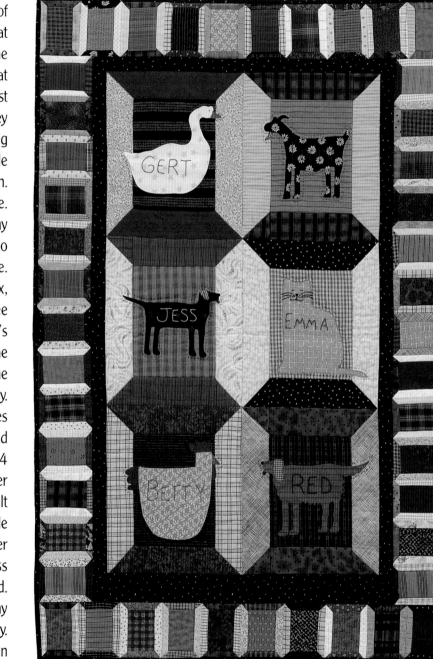

24

Materials: 44"-wide fabric

½ yd. total of assorted light fabrics
½ yd. total of assorted medium fabrics
½ yd. total of assorted dark fabrics
1½ yds. for backing
½ yd. for inner border and binding
Batting
Embroidery floss

Directions

All measurements include ¼"-wide seam allowances. Refer to pages 7–8 for sewing connector squares "c." Use the templates on pages 27–29. Refer to the individual block diagrams for positioning the appliqué pieces.

Large Spool Blocks

1. Cut and piece 6 blocks, using pieces #1–#4. Cutting directions are for 1 block.

Piece	Fabric	No. of Pieces	Dimensions
#1	Medium	1	6½" x 8½"
#2	Dark	2	2½" x 6½"
#3	Dark (to match #2)	4	2½" x 2½"
#4	Light	2	2½" x 12½"

Large Spool Block
Make 6.
Finished Size: 10" x 12"

2. Cut out and appliqué an animal on each spool. Embroider their names.

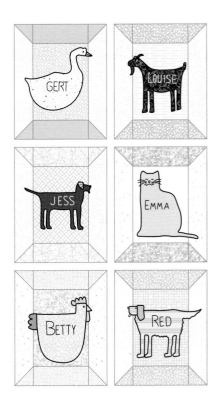

Small Spool Blocks

1. Cut and piece 46 blocks, using pieces #1–4. Cutting directions are for 1 block.

Piece	Fabric	No. of Pieces	Dimensions
#1	Medium	1	2½" x 3½"
#2	Dark	2	1" x 2½"
#3	Dark (to match #2)	4	1" x 1"
#4	Light	2	1" x 4½"

Small Spool Block
Make 46.
Finished Size: 3" x 4"

2. Join 10 Small Spool blocks to make each of the outer top and bottom borders. Join 13 Small Spool blocks to make each of the outer side borders.

Outer Top and Bottom Borders
Make 2.

Outer Side Borders
Make 2.

Assembly and Finishing

1. Referring to the quilt plan below and the color photo on page 24, sew the blocks together.
2. From the inner border fabric, cut:
 1 strip, 1½" x 20½", for the top border
 1 strip, 2½" x 20½", for the bottom border
 2 strips, each 1½" x 39½", for the side borders
3. Sew the top and bottom inner borders to the quilt top first, then add the side borders.
4. Sew the side outer borders to the quilt top first, then add the top and bottom borders.
5. Layer the quilt top with batting and backing; baste. Quilt as desired and bind the edges.

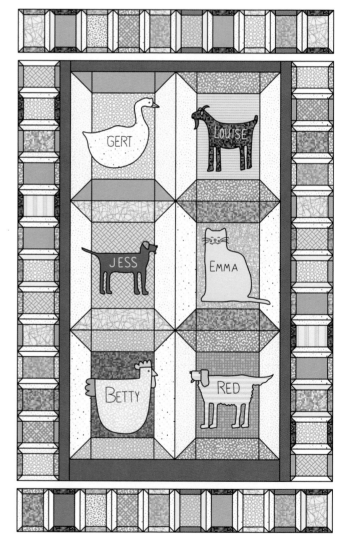

Quilt Plan

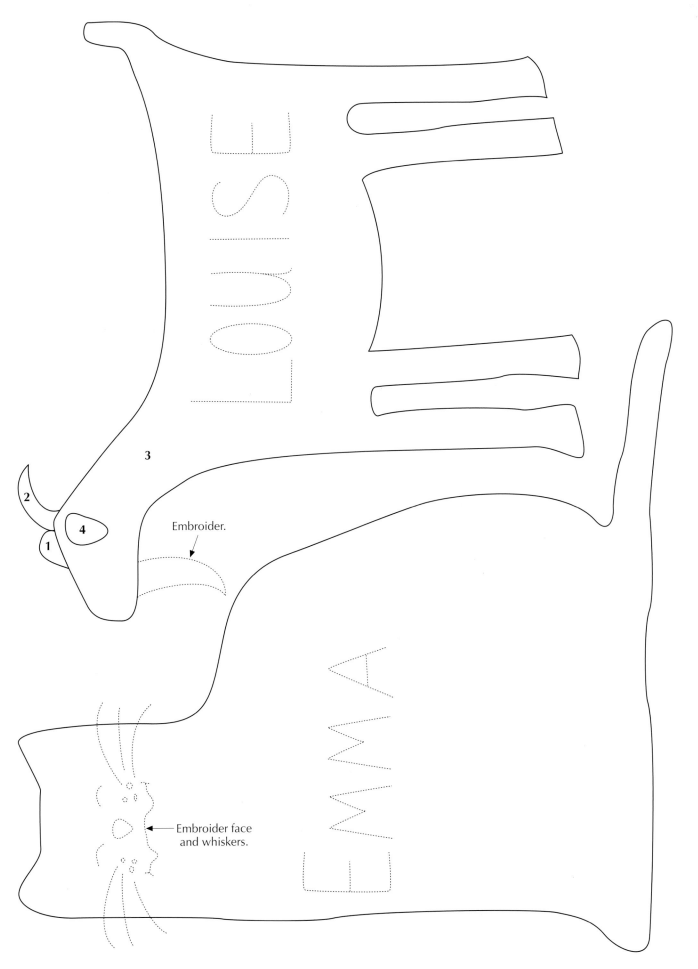

LOUISE

EMMA

3

2

4

1

Embroider.

Embroider face
and whiskers.

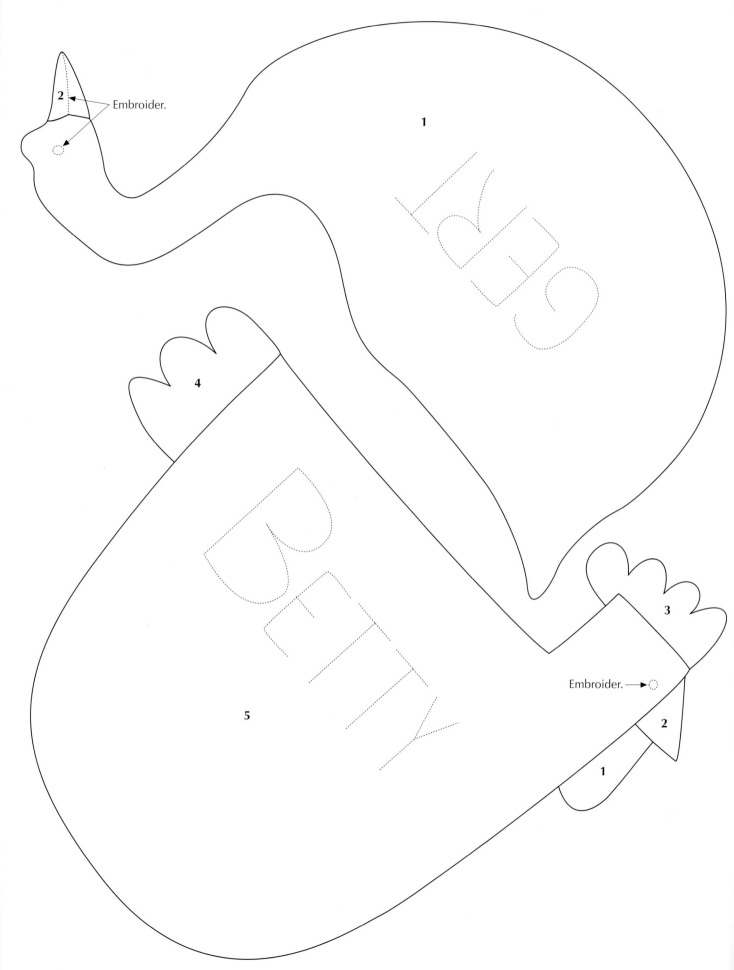

Embroider.

2

1

GET

4

BETTY

5

3

Embroider. →

2

1

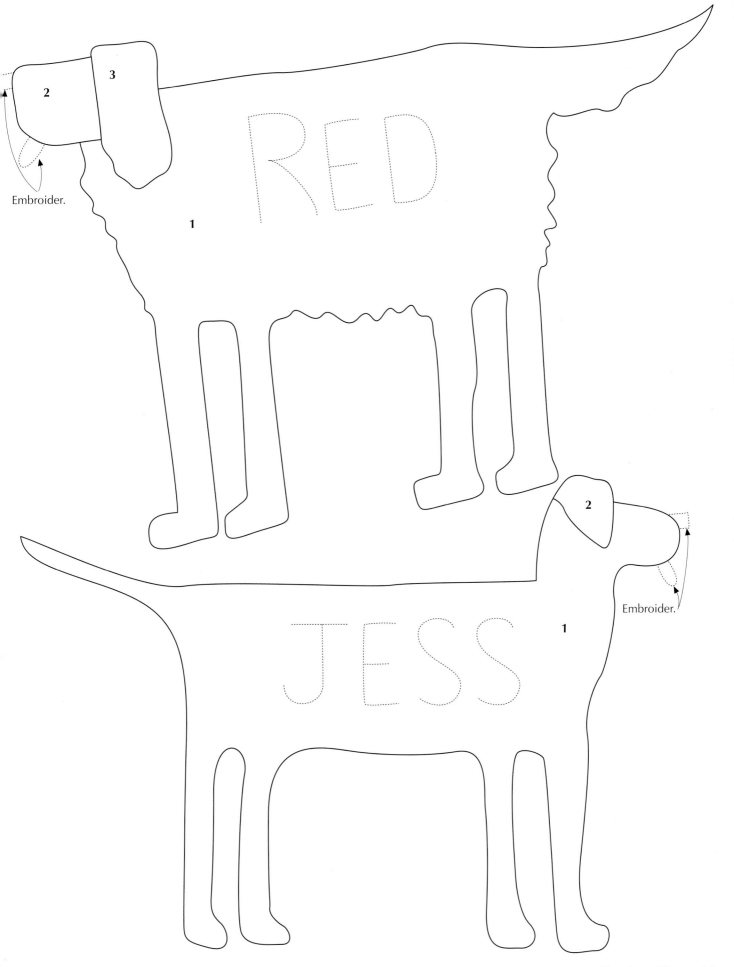

Embroider.

2

3

1

RED

Embroider.

2

1

JESS

Spring

Quilt Size: 34½" x 45½"

SPRING gardening in Iowa is a given. After a long, cold winter, Iowans can hardly wait to be outside, feeling the sun on their faces as they plant their "crops." The smell of the rich, black soil and the colorful tulips make up for the backache that accompanies those hectic days of planting seeds, bulbs, and pots of green things from the nursery. We both enjoy our large gardens, where we have fun playing with color, texture, and variety just as we do in quiltmaking. Mary has been known to say, "You can never have enough fabric!"

This hoarding theory, however, does not apply to zucchini, cucumbers, or green beans.

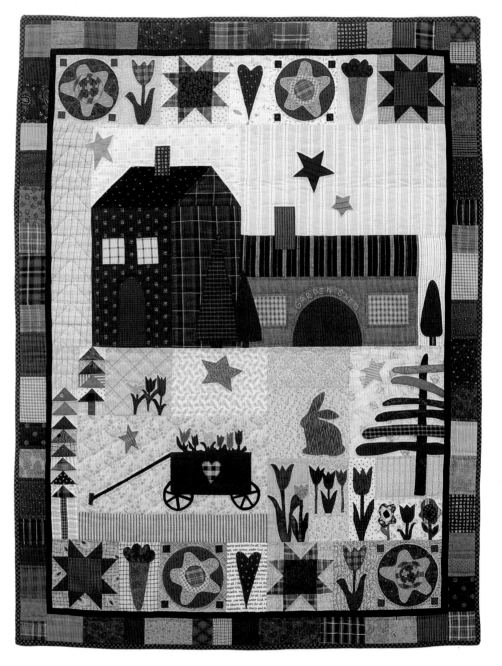

Materials: 44"-wide fabric

1¾ yds. total of assorted light background fabrics
½ yd. total of assorted darks for House and Shed blocks
1¼ yds. total of assorted mediums and darks for appliqués, patchwork, and pieced outer border
Scraps of assorted pinks, golds, and browns
⅛ yd. for inner border
1⅝ yds. for backing
¼ yd. for binding
Batting and embroidery floss

Directions

All measurements include ¼"-wide seam allowances. Refer to pages 7–8 for sewing connector squares "c." Use the templates on pages 35–39. Refer to the individual block diagrams for positioning the appliqué pieces.

House Block

Cut and piece 1 block, using pieces #1–#9. Appliqué pieces #10–#13.

Piece	Fabric	No. of Pieces	Dimensions
#1	Background	1	3½" x 16½"
#2	Background	1	3½" x 11½"
#3	Background	1	3½" x 3½"
#4	Background	1	Template #4
#5	Roof	1	3½" x 6½"
#6	Roof	1	Template #6
#7	House	1	Template #7
#8	House	1	5½" x 10½"
#9	House	1	6½" x 10½"
#10	Windows	2	2" x 2¼" (1½" x 1¾" if fusing)
#11	Chimney	1	1½" x 2½" (1" x 2" if fusing)
#12	Door	1	Template #12
#13	Star	1	Template #13

Shed Block

Cut and piece 1 block, using pieces #1–#4. Appliqué pieces #5–#12. Embroider "GARDEN SHED" above the door.

Piece	Fabric	No. of Pieces	Dimensions
#1	Background	1	8½" x 15½"
#2	Background	1	2½" x 8½"
#3	Roof	1	3½" x 13½"
#4	Shed	1	5½" x 13½"
#5	Windows	2	2½" x 3½" (2" x 3" if fusing)
#6	Chimney	1	2" x 3½" (1½" x 3" if fusing)
#7	Door	1	Template #7
#8	Heart	1	Template #8
#9	Tree trunk	1	Template #9
#10	Tree	1	Template #10
#11	Small star	1	Template #11
#12	Large star	1	Template #12

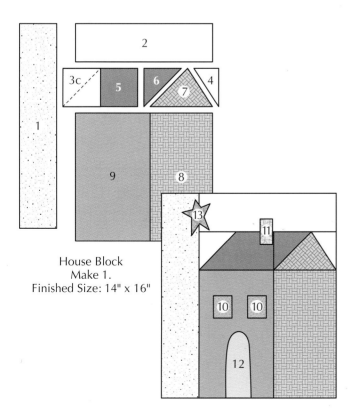

House Block
Make 1.
Finished Size: 14" x 16"

Shed Block
Make 1.
Finished Size: 15" x 16"

Short and Tall Tree Blocks

1. Cut and piece 12 flying-geese units, using pieces #1 and #2. Cutting directions are for 12 units.

Piece	Fabric	No. of Pieces	Dimensions
#1	Greens	12	1½" x 2½"
#2	Background	24	1½" x 1½"

 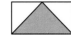

Flying Geese Unit
Make 12.
Finished Size: 2" x 1"

2. Cut and piece the Short and Tall Tree trunk sections, using pieces #1 and #2.

	Trunk (#1) Cut 1 each	Background (#2) Cut 2 each
Short Tree	1" x 1½"	1¼" x 1½"
Tall Tree	1" x 3½"	1¼" x 3½"

3. Join 4 flying-geese units; add them to the top of the Short Tree trunk section. Join 8 flying-geese units; add them to the top of the Tall Tree trunk section.

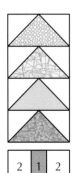

Short Tree Block
Make 1.
Finished Size: 2" x 5"

Tall Tree Block
Make 1.
Finished Size: 2" x 11"

Sawtooth Star Blocks

Cut and piece 4 blocks, using pieces #1–#4. Cutting directions are for 1 block.

Piece	Fabric	No. of Pieces	Dimensions
#1	Center	1	3" x 3"
#2	Star points	4	2⅛" x 2⅛" ◻
#3	Background	1	3¾" x 3¾" ⊠
#4	Background	4	1¾" x 1¾"

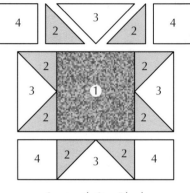

Sawtooth Star Block
Make 4.
Finished Size: 5" x 5"

Wagon Block

From the assorted light background fabrics, cut 1 rectangle, 7½" x 14½", and 1 rectangle, 2½" x 14½". Join the pieces as shown. From a dark fabric, cut 1 rectangle, 3½" x 6¼", for the wagon (piece #4). Appliqué pieces #1–#13.

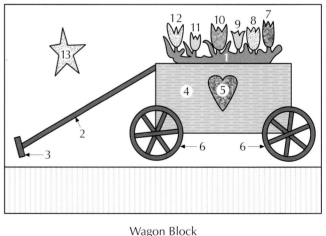

Wagon Block
Make 1.
Finished Size: 14" x 9"

Appliqué Blocks

1. From the assorted light background fabrics, cut the following pieces.

Block	No. of Pieces	Dimensions	Appliqué Pieces
Flower 1	2	3½" x 5½"	#1 and #2
Flower 2	1	5½" x 5½"	#1–#6
Flower 3	1	3½" x 6½"	#1–#4
Flower 4	1	2½" x 6½"	#1 and #2
Flower 5	1	3½" x 4½"	#1–#7
Flower 6	1	3½" x 5½"	#1–#10
Flower 7	4	5½" x 5½"	#1–#5
Star	1	5½" x 7½"	#1
Rabbit	1	5½" x 6½"	#1
Heart	2	3½" x 5½"	#1
Carrot	2	3½" x 5½"	#1 and #2

Flower 7 Block
Make 4.
Finished Size: 5" x 5"

Star Block
Make 1.
Finished Size: 7" x 5"

Rabbit Block
Make 1.
Finished Size: 6" x 5"

Heart Block
Make 2.
Finished Size:
3" x 5"

Carrot Block
Make 2.
Finished Size:
3" x 5"

2. Cut out and appliqué the appropriate pieces onto each block.

Flower 1 Block
Make 2.
Finished Size: 3" x 5"

Flower 2 Block
Make 1.
Finished Size: 5" x 5"

Flower 3 Block
Make 1.
Finished Size: 3" x 6"

Flower 4 Block
Make 1.
Finished Size: 2" x 6"

Flower 5 Block
Make 1.
Finished Size: 3" x 4"

Flower 6 Block
Make 1.
Finished Size: 5" x 3"

Large Tree Block

Cut 1 rectangle, 7½" x 8½", and 1 rectangle, 3½" x 5½". Join these pieces with Flower Blocks 4 and 6. Appliqué pieces #1–#8.

Large Tree Block
Make 1.
Finished Size: 7" x 14"

Assembly and Finishing

1. From the assorted light background fabrics, cut:
 1 spacer piece, 3½" x 6½"
 2 spacer pieces, each 2½" x 3½"
2. Referring to the quilt plan on page 34 and the color photo on page 30, sew all the blocks and spacer pieces together. Appliqué the overlapping trees (pieces #1–#4) between the House and Shed blocks.

3. From the inner border fabric, cut:
 2 strips, each 1" x 29½", for the top and bottom
 2 strips, 1" x 41½", for the sides
4. Sew the top and bottom inner borders to the quilt top first, then add the side borders.
5. The outer border is called a "chunk" border and is made up of 2½"-wide squares and rectangles. From the assorted medium and dark fabrics, cut a variety of strips, each 2½" wide. Crosscut the strips into random lengths, then join the pieces

to make the top and bottom borders, each 30½" long, and 2 side borders, each 45½" long.

6. Sew the top and bottom outer borders to the quilt top, then add the side borders.
7. Layer the quilt top with batting and backing; baste. Quilt as desired and bind the edges.

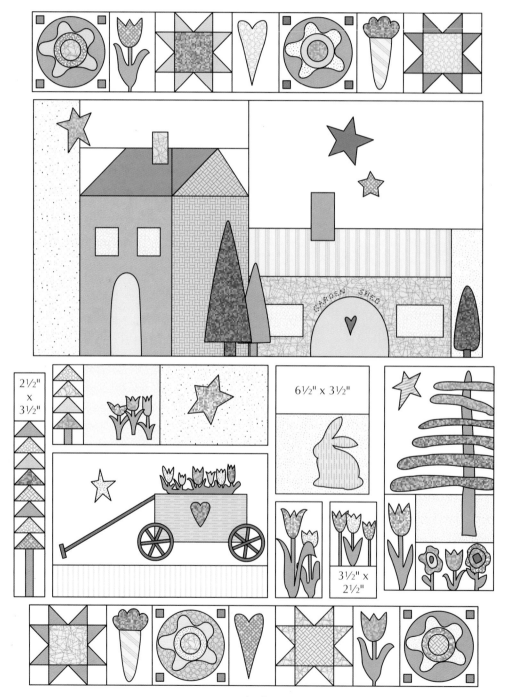

Quilt Plan

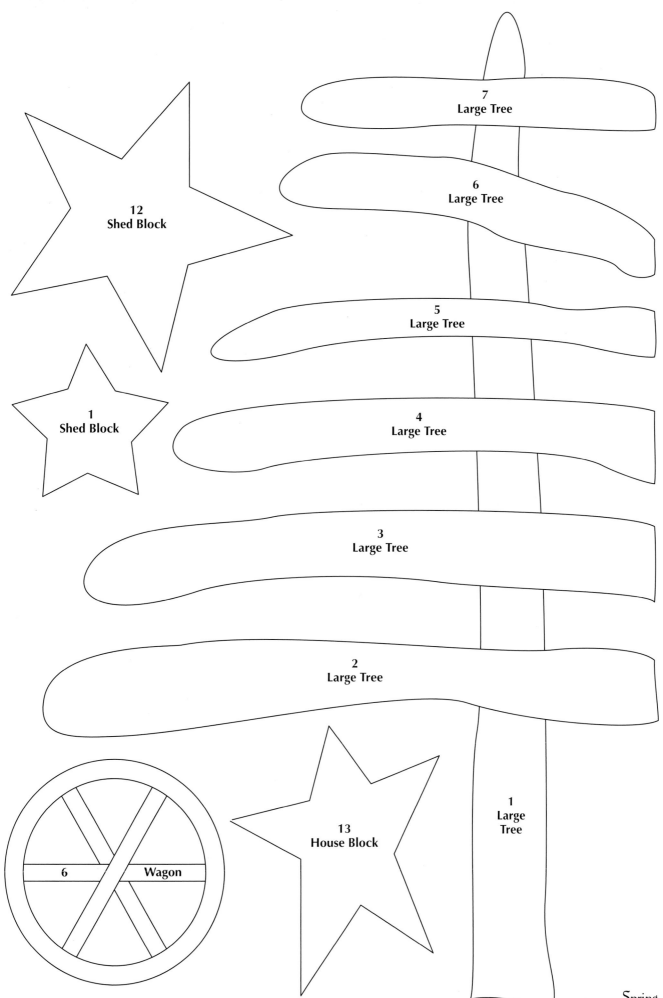

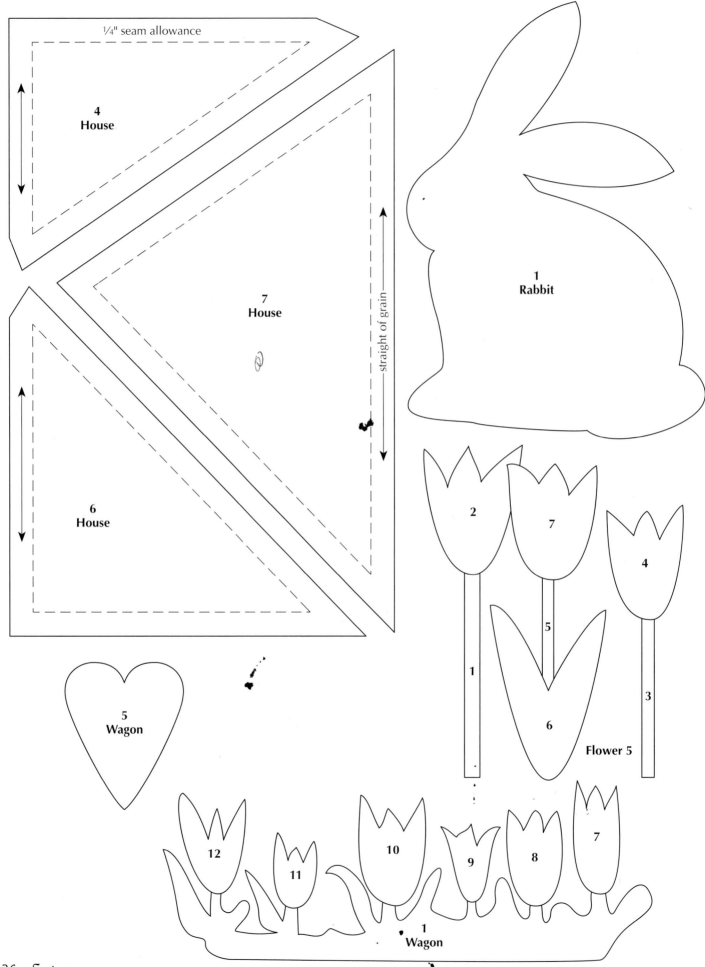

¼" seam allowance

4
House

7
House

straight of grain

1
Rabbit

6
House

2

7

4

5

1

6

3

5
Wagon

Flower 5

12

11

10

9

8

7

1
Wagon

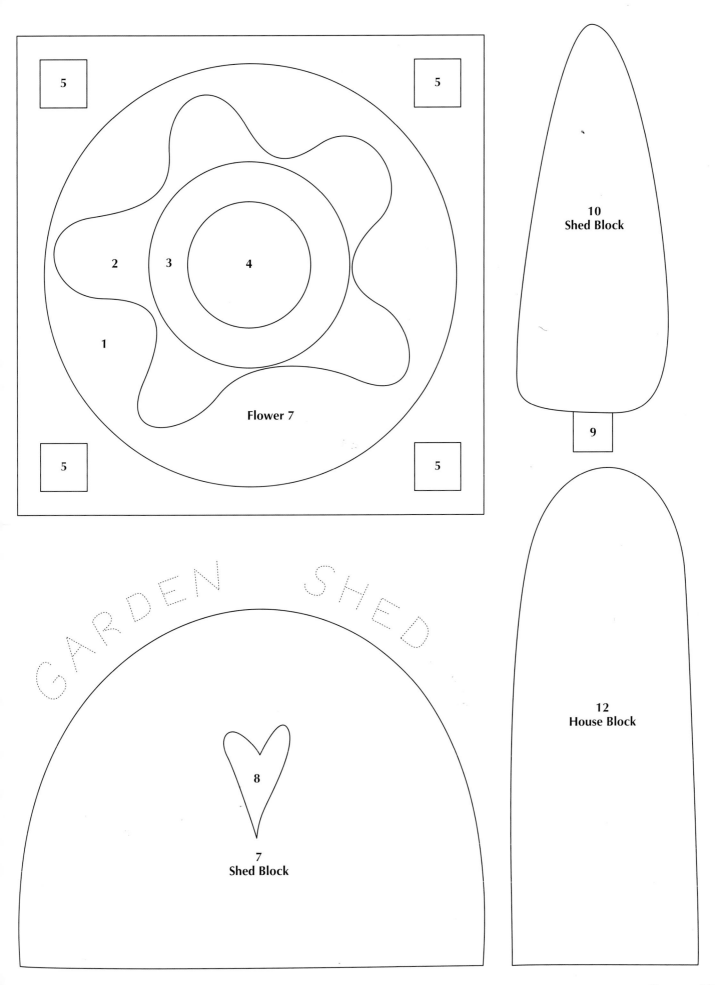

5

5

2 3 4

1

Flower 7

5

5

**10
Shed Block**

9

G A R D E N S H E D

8

7
Shed Block

**12
House Block**

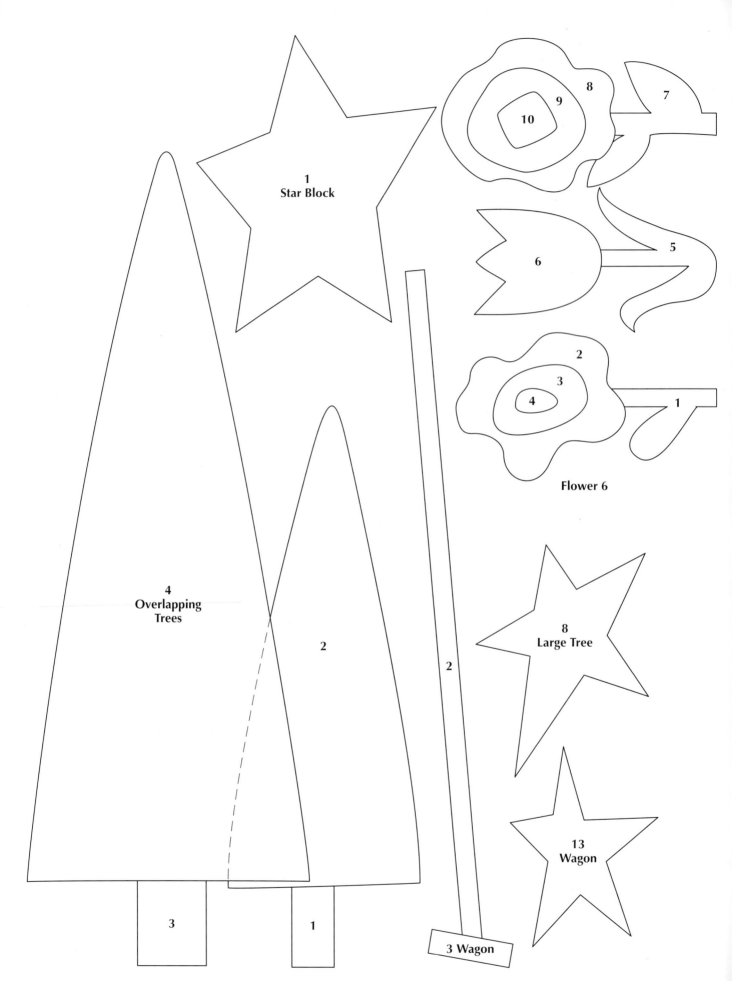

1
Star Block

8
9
10
7

6
5

2
3
4
1

Flower 6

4
Overlapping
Trees

2

2

8
Large Tree

13
Wagon

3

1

3 Wagon

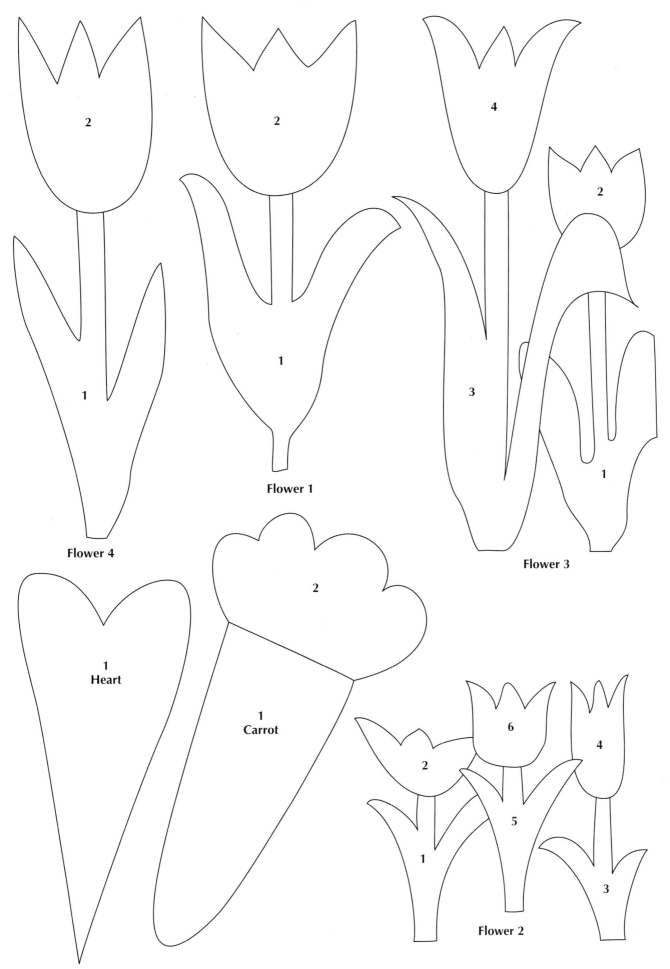

2

2

4

2

1

1

3

1

Flower 1

Flower 4

Flower 3

1
Heart

2

1
Carrot

6

2

4

5

1

3

Flower 2

Summer

Quilt Size: 27½" x 35½"

WHEN I LOOK at this quilt, I am reminded of summertime at the lake. Going to the lake for sunny days filled with water activities, including sailing, are some of my fondest memories. I remember the white houses with porches dotting the lake shore. The pleasure of a porch is something no one should miss. I grew up going to Grandma Andy's every Saturday afternoon, where we gently rocked back and forth in the porch swing or pushed each other vigorously in the hammock that hung at the opposite end of the porch. What memories!
—Mary

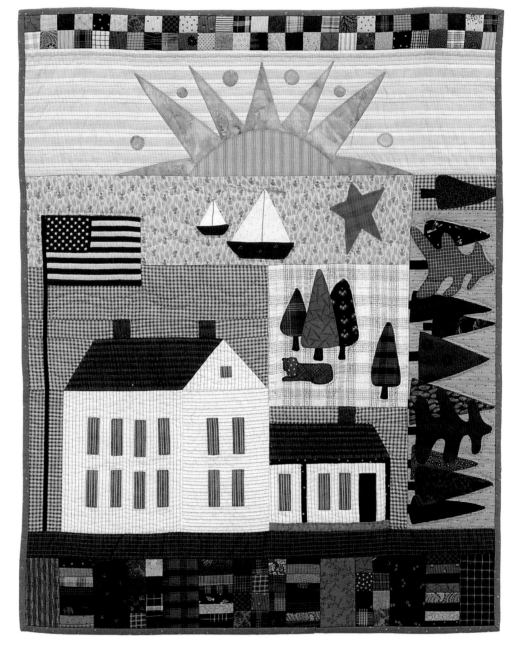

Materials: 44"-wide fabric

1½ yds. total of assorted background fabrics
¼ yd. white for house
¼ yd. gold for sun points
¼ yd. total each of assorted oranges, teals, greens, browns, reds, blues, and blacks
1 yd. for backing
¼ yd. for binding
Batting

Directions

All measurements include ¼"-wide seam allowances. Use the templates on pages 44–47. Refer to the individual block diagrams for positioning the appliqué pieces.

Large House Block

Cut and piece 1 block, using pieces #1–#12. Appliqué the windows (pieces #13 and #14).

Piece	Fabric	No. of Pieces	Dimensions
#1	Background	1	3½" x 14½"
#2	Background	1	1½" x 5½"
#3	Background	1	1½" x 4½"
#4	Background	1	1½" x 3½"
#5	Background	1	Template #5
#6	Background	1	Template #6
#7	Background	1	2½" x 8½"
#8	Chimney	2	1½" x 1½"
#9	Roof	1	Template #9
#10	House	1	Template #10
#11	House	1	5½" x 8½"
#12	House	1	7½" x 8½"
#13	Window	1	1⅛" x 1⅛" (⅝" x ⅝" if fusing)
#14	Windows	12	1⅛" x 2½" (⅝" x 2" if fusing)

Small House Block

Cut and piece 1 block, using pieces #1–#13. Appliqué the windows (piece #14).

Piece	Fabric	No. of Pieces	Dimensions
#1	Background	2	1½" x 4½"
#2	Background	1	1½" x 3½"
#3	Background	1	Template #3
#4	Chimney	1	1½" x 1½"
#5	Roof	1	Template #5
#6	House	1	2½" x 3¾"
#7	House	1	3½" x 3¾"
#8	House	1	1" x 1½"
#9	House	1	1" x 3¾"
#10	House trim	1	¾" x 7½"
#11	House trim	2	¾" x 3¾"
#12	Door	1	1½" x 3¼"
#13	Grass	1	1" x 7½"
#14	Windows	3	1⅛" x 2½" (⅝" x 2" if fusing)

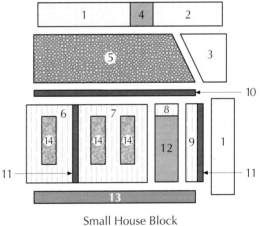

Small House Block
Make 1.
Finished Size: 8" x 7"

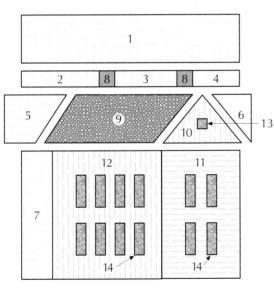

Large House Block
Make 1.
Finished Size: 14" x 15"

Appliqué Blocks

1. From the assorted background fabrics, cut the following pieces. For the Sun block, cut 2 each of pieces #3–#5. For the Row of Trees block, cut 2 each of pieces #3, #4, #7, and #8.

Block	Dimensions	Appliqué Pieces
Sun	7½" x 27½"	#1–#5
Sailboat	5½" x 22½"	#1–#6
Trees and Dog	8½" x 8½"	#1–#10
Single Tree	2½" x 5½"	#1 and #2
Row of Trees	5½" x 18½"	#1–#14

2. Appliqué the appropriate pieces onto each block.

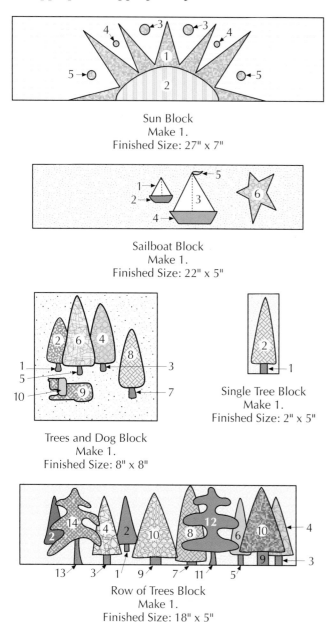

Sun Block
Make 1.
Finished Size: 27" x 7"

Sailboat Block
Make 1.
Finished Size: 22" x 5"

Trees and Dog Block
Make 1.
Finished Size: 8" x 8"

Single Tree Block
Make 1.
Finished Size: 2" x 5"

Row of Trees Block
Make 1.
Finished Size: 18" x 5"

Pieced Borders

1. From the assorted light scraps, cut 27 squares, each 1½" x 1½". From the assorted medium and dark scraps, cut 27 squares, each 1½" x 1½".
2. Sew the light and medium or dark squares into 27 pairs. Join the pairs, alternating the light and medium or dark as shown, to make the top border.

Top Border
Make 1.

3. From the assorted fabrics, cut:
 6 rectangles, each 2½" x 4½"
 28 squares, each 1½" x 1½"
 32 rectangles, each 1" x 2½"
4. Assemble the squares and small rectangles into units as shown. Join the units to make the bottom border.

Bottom Border
Make 1.

Assembly and Finishing

1. From a dark fabric, cut 1 strip, 2½" x 27½", for the bottom inner border.
2. Referring to the quilt plan on page 43 and the color photo on page 40, sew all the blocks and borders together.
3. From the black fabric, cut 1 strip, ¾" x 18¼" (or ¼" wide if fusing), for the flagpole. Appliqué in place. Appliqué a purchased flag at the top of the flagpole. Refer to the color photo.
4. Layer the quilt top with batting and backing; baste. Quilt as desired and bind the edges.

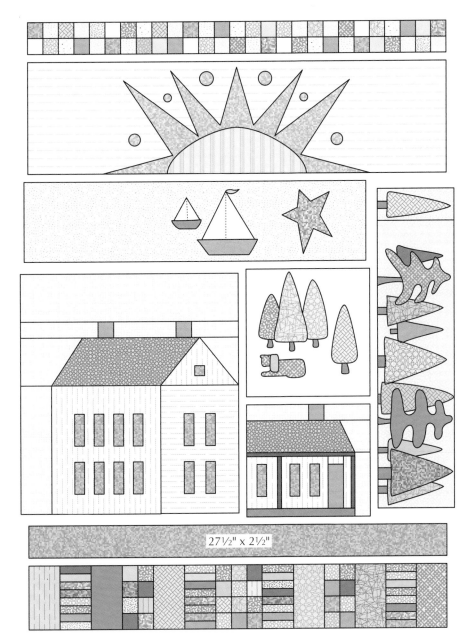

Quilt Plan

27½" x 2½"

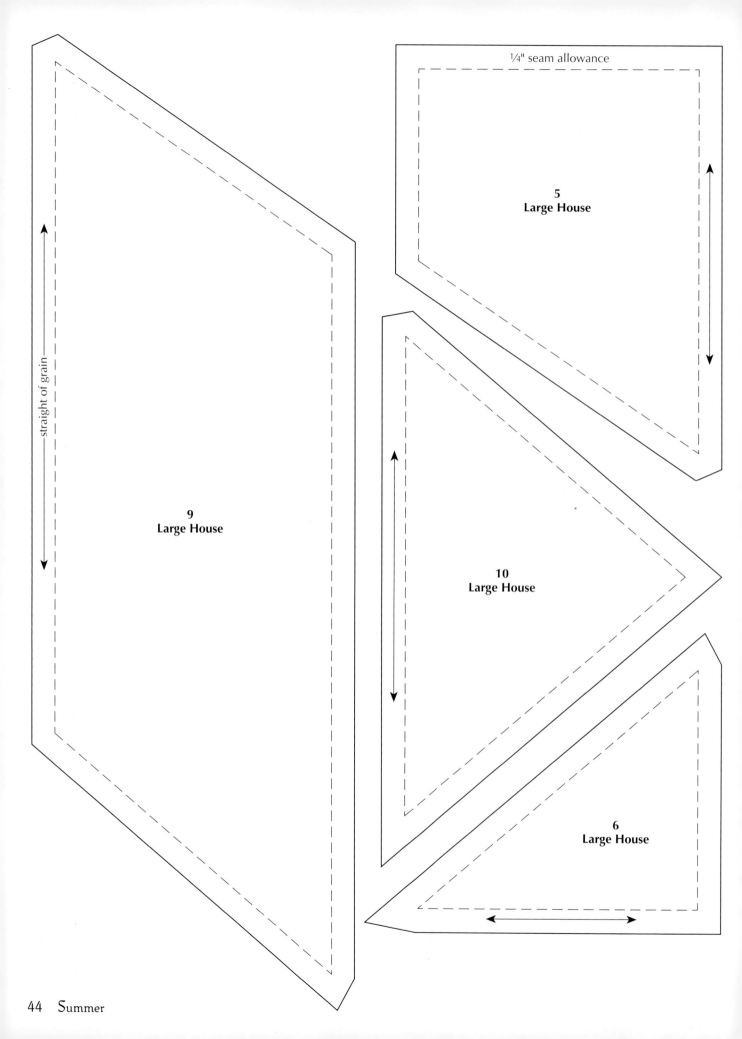

¼" seam allowance

5
Large House

straight of grain

9
Large House

10
Large House

6
Large House

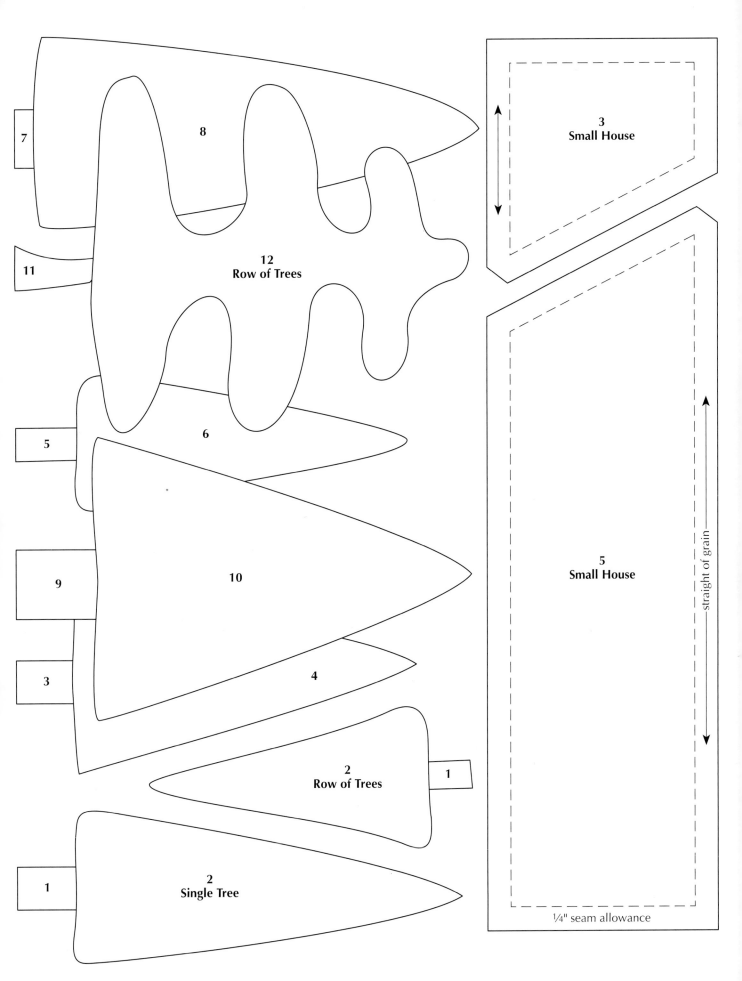

7

8

11

12
Row of Trees

5

6

9

10

3

4

2
Row of Trees

1

1

2
Single Tree

3
Small House

5
Small House

straight of grain

¼" seam allowance

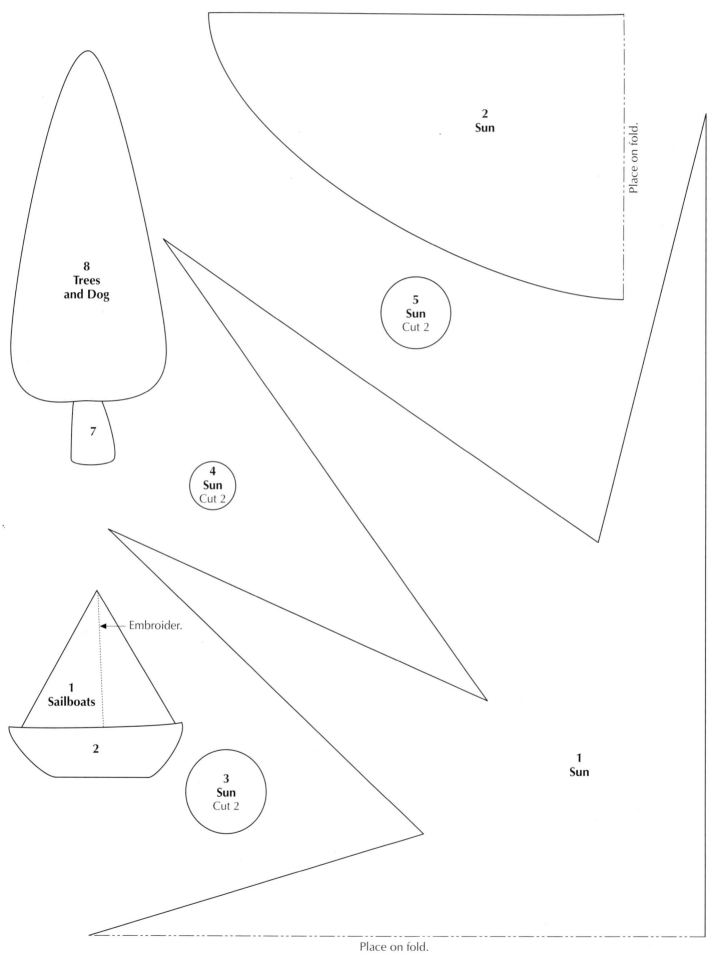

2
Sun

Place on fold.

8
Trees
and Dog

5
Sun
Cut 2

7

4
Sun
Cut 2

Embroider.

1
Sailboats

2

3
Sun
Cut 2

1
Sun

Place on fold.

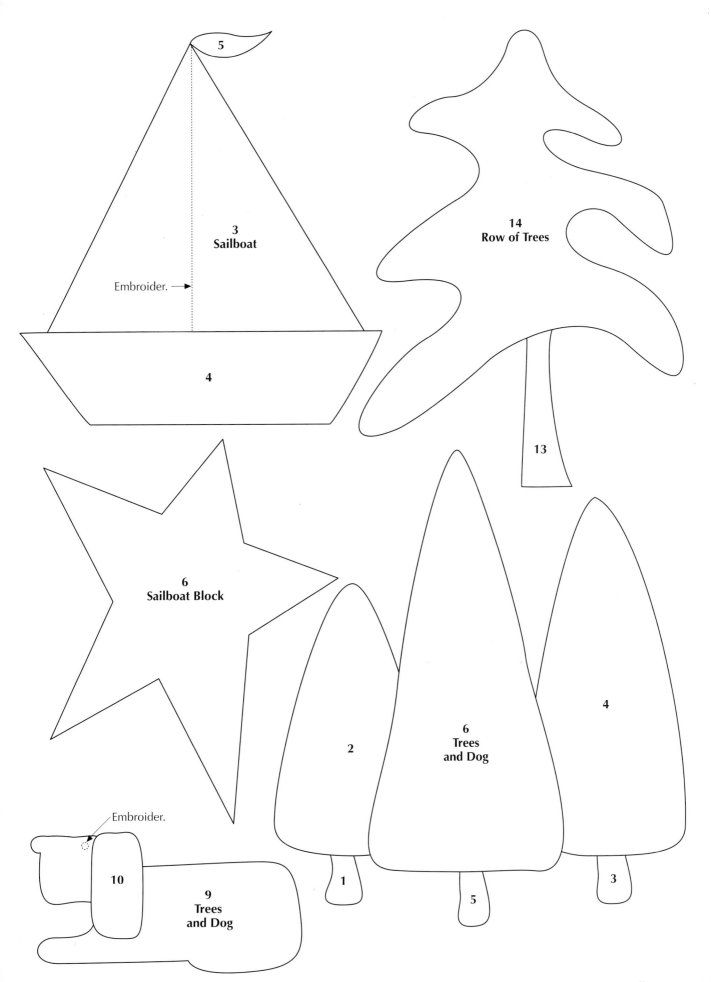

**3
Sailboat**

Embroider. →

4

5

**14
Row of Trees**

13

**6
Sailboat Block**

2

1

**6
Trees
and Dog**

5

4

3

Embroider.

10

**9
Trees
and Dog**

Fall Harvest

Quilt Size: 28½" x 43½"

OUTSIDE our quilt shop, right beside the door, we have a quilt hanger where we hang seasonal quilts throughout the year. Thanksgiving was almost always ignored because everyone was anxious to get on with Christmas, so we designed a wall quilt just for our shop entrance. It's our welcome to everyone visiting Country Threads during the Thanksgiving season, when our neighbors are thankful for a bountiful harvest.

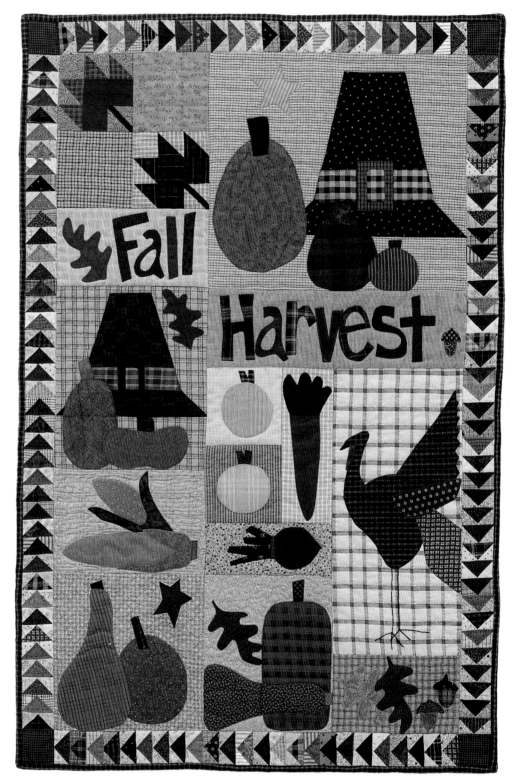

Materials: *44"-wide fabric*

2 yds. total of assorted light background fabrics
¾ yd. each of assorted oranges and golds
⅓ yd. each of dark blue and black for hats
¼ yd. red-brown for turkey
Scraps of assorted reds, greens, yellows, browns, rusts, purples, and teals
1⅜ yds. for backing
¼ yd. for binding
Batting

Directions

All measurements include ¼"-wide seam allowances. Use the templates on the pullout pattern. Refer to the individual block diagrams for positioning the appliqué pieces.

Leaf Blocks

1. Cut and piece 2 blocks, using pieces #1–#4. Appliqué piece #5 to a light 2" square (piece #1) before assembling the block. Cutting directions are for 1 block.

Piece	Fabric	No. of Pieces	Dimensions
#1	Light	2	2" x 2"
#2	Light	2	2⅜" x 2⅜" ◻
#3	Dark	2	2⅜" x 2⅜" ◻
#4	Dark	3	2" x 2"
#5	Dark	1	¾" x 2¼"

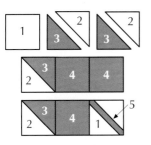

Leaf Block
Make 2.
Finished Size: 4½" x 4½"

2. From 2 light background fabrics, cut 2 squares, each 5" x 5". Join the Leaf blocks and squares.

Appliqué Blocks

1. From the assorted light background fabrics, cut the following pieces.

Block	No. of Pieces	Dimensions	Appliqué Pieces
Large Hat	1	14" x 15½"	#1–#10
Fall	1	5" x 9½"	#1–#5
Harvest	1	5" x 15½"	#1–#9
Small Hat	1	9½" x 11"	#1–#8
Onion	2	5" x 5"	#1 and #2
Carrot	1	3½" x 9½"	#1 and #2
Beet	1	3½" x 8"	#1–#3
Corn	1	6½" x 9½"	#1–#5
Pumpkin 1	1	9½" x 9½"	#1–#5
Pumpkin 2	1	8" x 9½"	#1–#5
Turkey	1	8" x 17"	#1–#5
Leaves & Acorns	1	5" x 8"	#1–#6

2. Appliqué the appropriate pieces onto each block.

Fall Block
Make 1.
Finished Size: 9 x 4½"

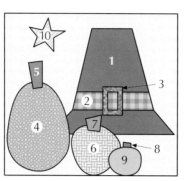

Large Hat Block
Make 1.
Finished Size: 15" x 13½"

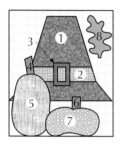

Small Hat Block
Make 1.
Finished Size: 9" x 10½"

Onion Block
Make 2.
Finished Size: 4½" x 4½"

Harvest Block
Make 1.
Finished Size: 15" x 4½"

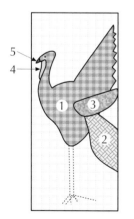

Turkey Block
Make 1.
Finished Size: 7½" x 16½"

Carrot Block
Make 1.
Finished Size: 3" x 9"

Leaves and Acorns Block
Make 1.
Finished Size: 7½" x 4½"

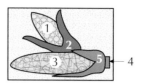

Corn Block
Make 1.
Finished Size: 9" x 6"

Beet Block
Make 1.
Finished Size: 7½" x 3"

Pumpkin 1 Block
Make 1.
Finished Size: 9" x 9"

Pumpkin 2 Block
Make 1.
Finished Size: 7½" x 9"

Flying Geese Borders

1. Cut and piece 126 flying-geese units, using pieces #1 and #2. Cutting directions are for 126 units.

Piece	Fabric	No. of Pieces	Dimensions
#1	Darks	32	3¼" x 3¼" ⊠
#2	Lights	126	1⅞" x 1⅞" ◻
#3	Darks	4	2½" x 2½"

Flying-Geese Unit
Make 126.
Finished Size: 2" x 1"

2. Join 39 flying-geese units to make each of the 2 side borders. Join 24 units to make each of the top and bottom borders. Add a dark square (piece #3) to each end of the top and bottom borders.

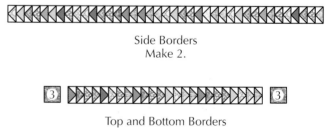

Side Borders
Make 2.

Top and Bottom Borders
Make 2.

Assembly and Finishing

1. Referring to the quilt plan below and the color photo on page 48, sew all the blocks together.
2. Sew the side Flying Geese borders to the quilt top first, then add the top and bottom borders.
3. Layer the quilt top with batting and backing; baste. Quilt as desired and bind the edges.

Quilt Plan

Winter Solstice

Quilt Size: 38½" x 46½"

Y EARS AGO, we had sheep at Country Threads. Their wool made them much more comfortable in the winter. But when spring rolled around, we needed someone to come out and shear them. No one was ever eager to come all the way out to the farm when our total sheep population was only five or six, and each weighed a lot more than the average market sheep. When they became very old and went on to sheep heaven, we did not replace them. These beloved old sheep—Twinkle Toes, Freckles, Mike, Munchkin, and Rose—produced wool for our business for many years, and they are remembered with fondness.

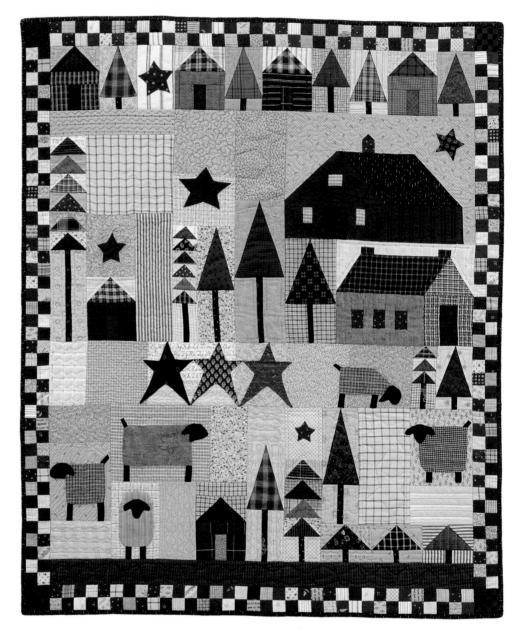

Materials: 44"-wide fabric

2 yds. total of light background fabrics
½ yd. total of assorted reds
½ yd. total of assorted greens and blues
⅛ yd. dark fabric for bottom spacer
Scraps of assorted beiges and blacks
1½ yds. for backing
¼ yd. for binding
Batting

Directions

All measurements include ¼"-wide seam allowances. The "r" next to a number means you flip the piece over and cut that number of reverse pieces. Refer to pages 7–8 for sewing connector squares "c." Use the templates on pages 59–64. Refer to individual block diagrams for positioning appliqué pieces.

Small Barn Block

Cut and piece 1 block, using pieces #1–#14.

Piece	Fabric	No. of Pieces	Dimensions
#1	Background	2	1½" x 2½"
#2	Background	2	1" x 1½"
#3	Background	1	1½" x 5½"
#4	Background	1 and 1r	Template #4
#5	Chimney	2	1" x 1½"
#6	Roof	1	Template #6
#7	Barn	1	Template #7
#8	Barn	2	1¾" x 4½"
#9	Barn	1	1¼" x 2"
#10	Barn side	2	1¾" x 4½"
#11	Barn side	6	1½" x 1¾"
#12	Barn side	2	1¼" x 4½"
#13	Window	3	1½" x 2"
#14	Door	1	2" x 3¾"

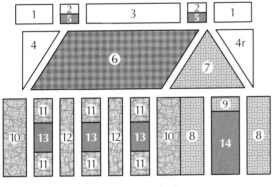

Small Barn Block
Make 1.
Finished Size: 11" x 8"

Large Barn Block

Cut and piece 1 block, using pieces #1–#19. Appliqué pieces #20 and #21.

Piece	Fabric	No. of Pieces	Dimensions
#1	Background	1	3½" x 6½"
#2	Background	1	1½" x 2"
#3	Background	2	1" x 1"
#4	Background	1	3½" x 8½"
#5	Background	1	Template #5
#6	Background	1	Template #6
#7	Background	1	1½" x 3½"
#8	Black	1	1" x 1½"
#9	Chimney	1	1½" x 1½"
#10	Roof	1	Template #10
#11	Barn	1	Template #11
#12	Barn	2	2" x 3½"
#13	Barn	2	1" x 1¼"
#14	Barn	2	1¼" x 1¾"
#15	Barn	2	1¼" x 3½"
#16	Barn	1	1" x 2½"
#17	Barn side	1	3½" x 6½"
#18	Window	2	1¼" x 1¾"
#19	Door	1	2½" x 3"
#20	Window	1	1¼" x 1½" (¾" x 1" if fusing)
#21	Star	1	Template #21

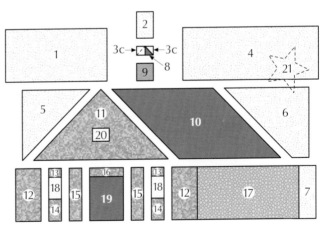

Large Barn Block
Make 1.
Finished Size: 15" x 10"

Small House Blocks

Cut and piece 6 blocks, using pieces #1–#5. Cutting directions are for 6 blocks.

Piece	Fabric	No. of Pieces	Dimensions
#1	Background	12	2½" x 2½" ◻
#2	Roof	6	2½" x 4½"
#3	House	6	1½" x 4½"
#4	House	12	2" x 2½"
#5	Door	6	1½" x 2½"

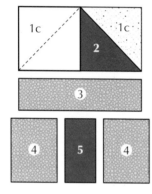

Small House Block
Make 6.
Finished Size: 4" x 5"

Short and Tall Tree 1 Blocks

1. Cut and piece 9 small flying-geese units, using pieces #1 and #2. Cutting directions are for 9 units.

Piece	Fabric	No. of Pieces	Dimensions
#1	Darks	9	1½" x 2½"
#2	Lights	18	1½" x 1½"

Small Flying-Geese Unit
Make 9.
Finished Size: 2" x 1"

2. Cut and piece the Short and Tall Tree 1 trunk sections, using pieces #1 and #2.

	Trunk (#1) Cut 1 each	Background (#2) Cut 2 each
Short Tree 1	1" x 2½"	1¼" x 2½"
Tall Tree 1	1" x 3½"	1¼" x 3½"

3. Join 3 flying-geese units and add to the top of the Short Tree 1 trunk section. Join 6 flying-geese units and add to the top of the Tall Tree 1 trunk section.

Short Tree 1 Block
Make 1.
Finished Size: 2" x 5"

Tall Tree 1 Block
Make 1.
Finished Size: 2" x 9"

Short and Tall Tree 2 Blocks

1. Cut and piece 10 large flying-geese units, using pieces #1 and #2. Cutting directions are for 10 units.

Piece	Fabric	No. of Pieces	Dimensions
#1	Darks	10	2" x 3½"
#2	Lights	20	2" x 2"

Large Flying-Geese Unit
Make 10.
Finished Size: 3" x 1½"

2. Cut and piece the Short and Tall Tree 2 trunk sections, using pieces #1 and #2.

	Trunk (#1) Cut 1 each	Background (#2) Cut 2 each
Short Tree 2	1" x 2½"	1¾" x 2½"
Tall Tree 2	1" x 7½"	1¾" x 7½"

3. Join 4 flying-geese units; add to the top of the Short Tree 2 trunk section. Join 6 flying-geese units; add to the top of the Tall Tree 2 trunk section.

Short Tree 2 Block
Make 1.
Finished Size: 3" x 8"

Tall Tree 2 Block
Make 1.
Finished Size: 3" x 16"

Tree 1 Blocks

Cut and piece 3 blocks, using pieces #1–#4. Cutting directions are for 3 blocks.

Piece	Fabric	No. of Pieces	Dimensions
#1	Background	6	2½" x 2½"
#2	Background	6	1½" x 2¼"
#3	Tree	3	2½" x 4½"
#4	Trunk	3	1" x 1½"

Tree 1 Block
Make 3.
Finished Size: 4" x 3"

Tree 2 Blocks

Cut and piece 5 blocks, using pieces #1–#4. Cutting directions are for 5 blocks.

Piece	Fabric	No. of Pieces	Dimensions
#1	Background	5 and 5r	Template #1
#2	Background	10	1½" x 1¾"
#3	Tree	5	Template #3
#4	Trunk	5	1" x 1½"

Tree 2 Block
Make 5.
Finished Size: 3" x 5"

Tree 3 Block

Cut and piece 1 block, using pieces #1–#4.

Piece	Fabric	No. of Pieces	Dimensions
#1	Background	1 and 1r	Template #1
#2	Background	2	1¾" x 2½"
#3	Tree	1	Template #3
#4	Trunk	1	1" x 2½"

Tree 3 Block
Make 1.
Finished Size: 3" x 5"

Tree 4 Block

Cut and piece 1 block, using pieces #1–#4.

Piece	Fabric	No. of Pieces	Dimensions
#1	Background	1 and 1r	Template #1
#2	Background	2	1¾" x 3½"
#3	Tree	1	Template #3
#4	Trunk	1	1" x 3½"

Tree 4 Block
Make 1.
Finished Size: 3" x 9"

Tree 6 Block

Cut and piece 1 block, using pieces #1–#4.

Piece	Fabric	No. of Pieces	Dimensions
#1	Background	1 and 1r	Template #1
#2	Background	2	2¼" x 3½"
#3	Tree	1	Template #3
#4	Trunk	1	1" x 3½"

Tree 6 Block
Make 1.
Finished Size: 4" x 8"

Tree 5 Blocks

Cut and piece 2 blocks, using pieces #1–#4.
Cutting directions are for 2 blocks.

Piece	Fabric	No. of Pieces	Dimensions
#1	Background	2 and 2r	Template #1
#2	Background	4	1¾" x 4½"
#3	Tree	2	Template #3
#4	Trunk	2	1" x 4½"

Tree 5 Block
Make 2.
Finished Size: 3" x 9"

Tree 7 Block

Cut and piece 1 block, using pieces #1–#4.

Piece	Fabric	No. of Pieces	Dimensions
#1	Background	1 and 1r	Template #1
#2	Background	2	2¼" x 5½"
#3	Tree	1	Template #3
#4	Trunk	1	1" x 5½"

Tree 7 Block
Make 1.
Finished Size: 4" x 11"

Appliqué Blocks

1. From the assorted background fabrics, cut the following pieces:

Block	Dimensions	Appliqué Pieces
Sheep 1	5½" x 6½"	#1–#4
Sheep 2	4½" x 6½"	#1–#3
Sheep 3	6½" x 8½"	#1–#4
Sheep 4	5½" x 6½"	#1–#4

2. Appliqué the appropriate pieces onto each block.

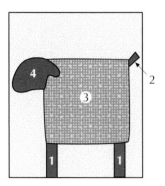

Sheep 1 Block
Make 1.
Finished Size: 5" x 6"

Sheep 2 Block
Make 1.
Finished Size: 4" x 6"

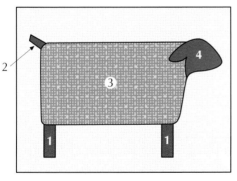

Sheep 3 Block
Make 1.
Finished Size: 8" x 6"

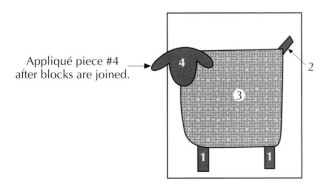

Appliqué piece #4 after blocks are joined.

Sheep 4 Block
Make 1.
Finished Size: 5" x 6"

Pieced Borders

1. From the assorted red and light scraps, cut 152 red squares, each 1½" x 1½", and 152 light squares, each 1½" x 1½".
2. Sew the red and light squares into pairs. Join 42 pairs to make each of the side borders. Join 34 pairs to make each of the top and bottom borders. Cut 4 red squares, each 2½" x 2½". Add 1 square to each end of the top and bottom borders.

Side Borders
Make 2.

Top and Bottom Borders
Make 2.

Assembly and Finishing

1. From the assorted background fabrics, cut the following spacer pieces.

No. of Pieces	Dimensions
1	1½" x 4½"
1	2½" x 7½"
1	2½" x 10½"
1	3½" x 3½"
1	3½" x 4½"
5	3½" x 5½"
2	3½" x 6½"
1	3½" x 7½"
1	3½" x 10½"
3	4½" x 5½"
1	4½" x 7½"
1	4½" x 9½"
4	5½" x 5½"
1	6½" x 7½"
1	2½" x 34½"

2. Referring to the quilt plan below and the color photo on page 52, sew all the blocks and spacer pieces together.

3. Sew the side pieced borders to the quilt top first, then add the top and bottom borders.

4. Cut out and appliqué Sheep 5 and appliqué the head (piece #4) of Sheep 4. Cut out and appliqué

the small, medium, large, and extra-large stars. Refer to the quilt plan and color photo for placement.

5. Layer the quilt top with batting and backing; baste. Quilt as desired and bind the edges.

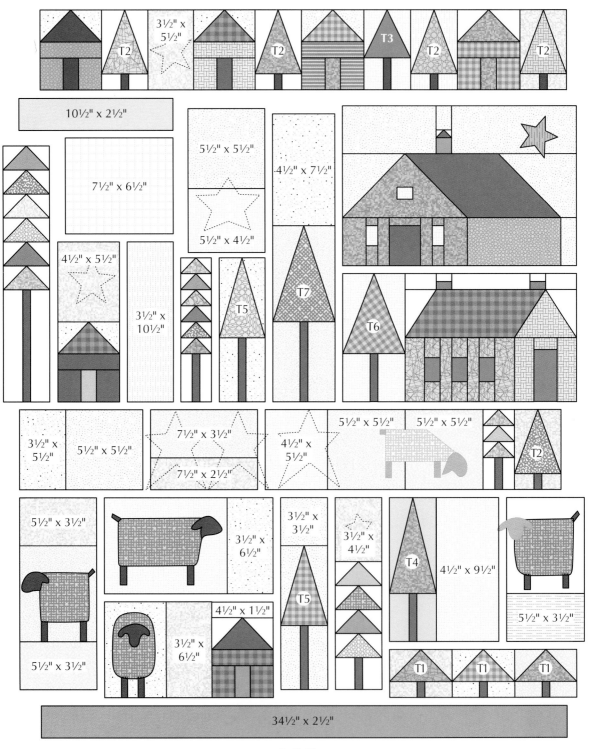

Quilt Plan

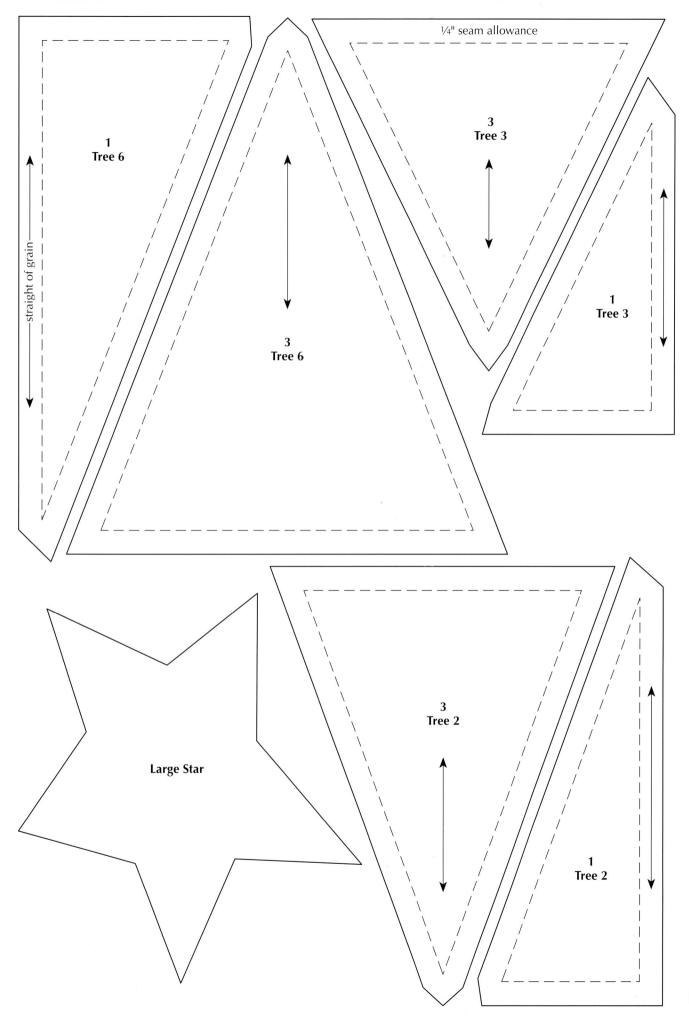

1
Tree 6

straight of grain

3
Tree 6

¼" seam allowance

3
Tree 3

1
Tree 3

Large Star

3
Tree 2

1
Tree 2

¼" seam allowance

59

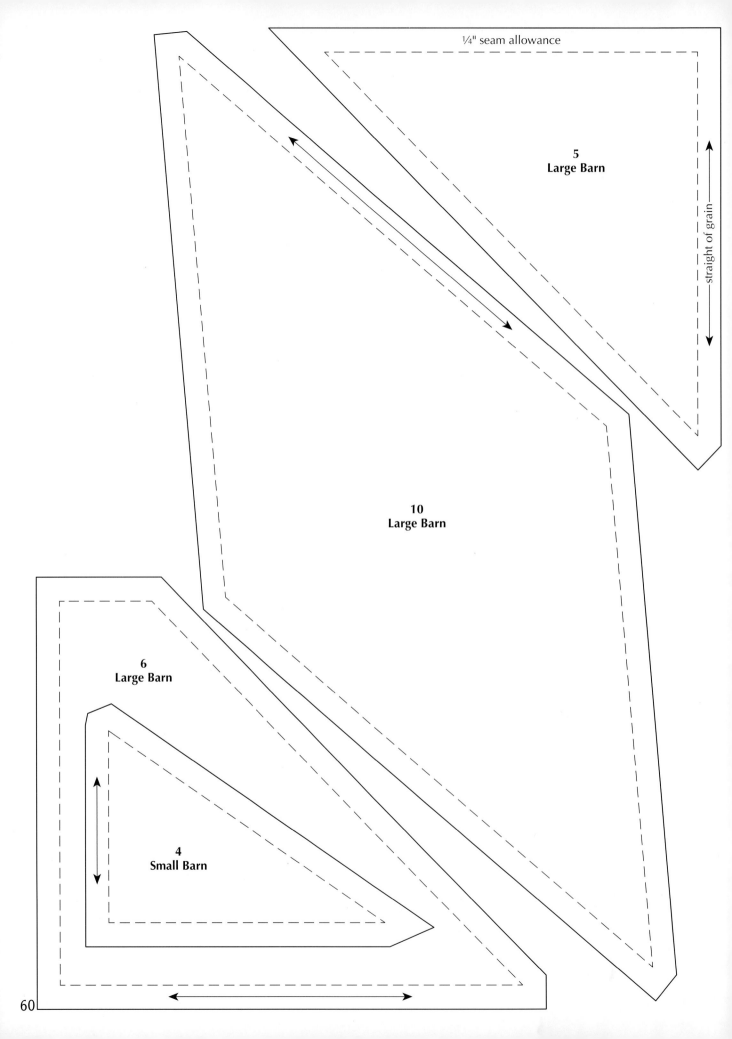

¼" seam allowance

5
Large Barn

straight of grain

10
Large Barn

6
Large Barn

4
Small Barn

60

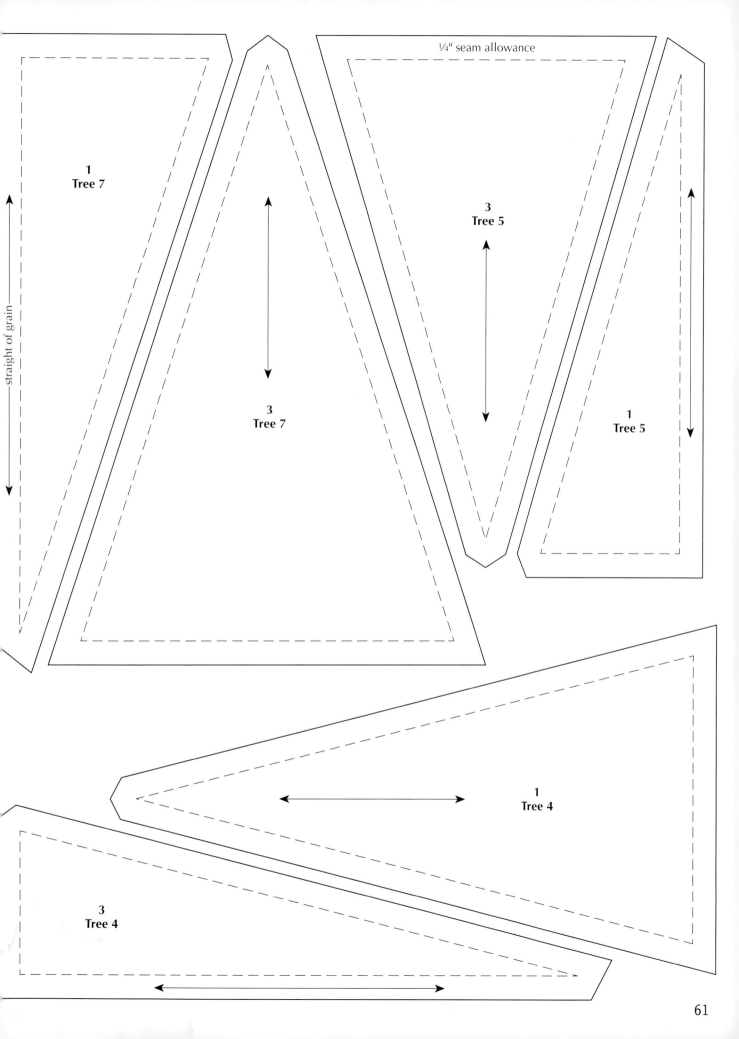

1
Tree 7

¼" seam allowance

3
Tree 5

straight of grain

3
Tree 7

1
Tree 5

1
Tree 4

3
Tree 4

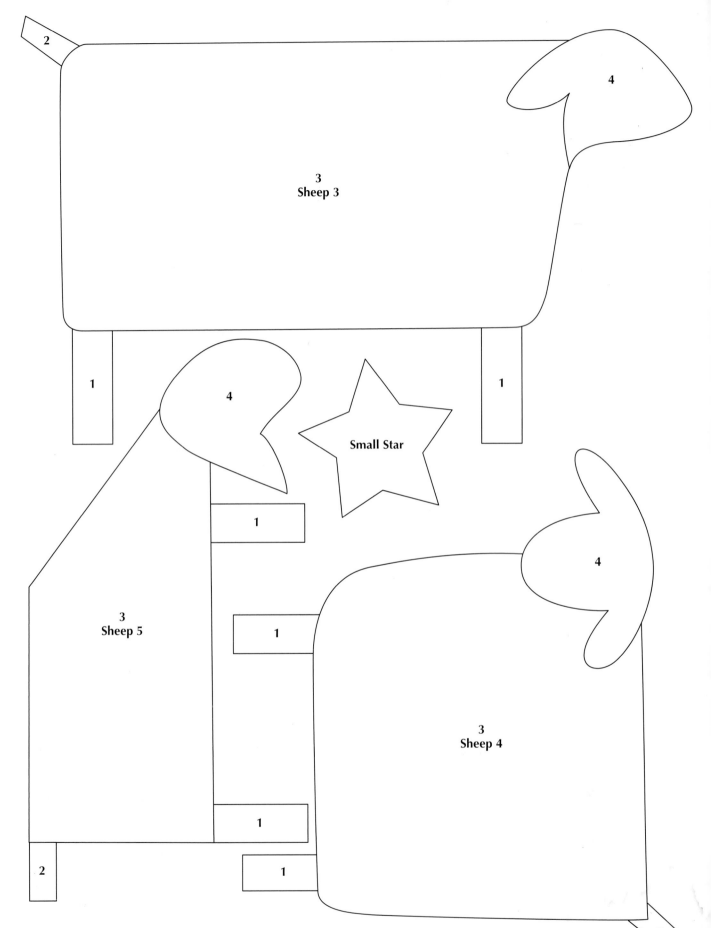

2

3
Sheep 3

4

1

1

4

Small Star

1

3
Sheep 5

1

4

1

3
Sheep 4

1

2

1

2

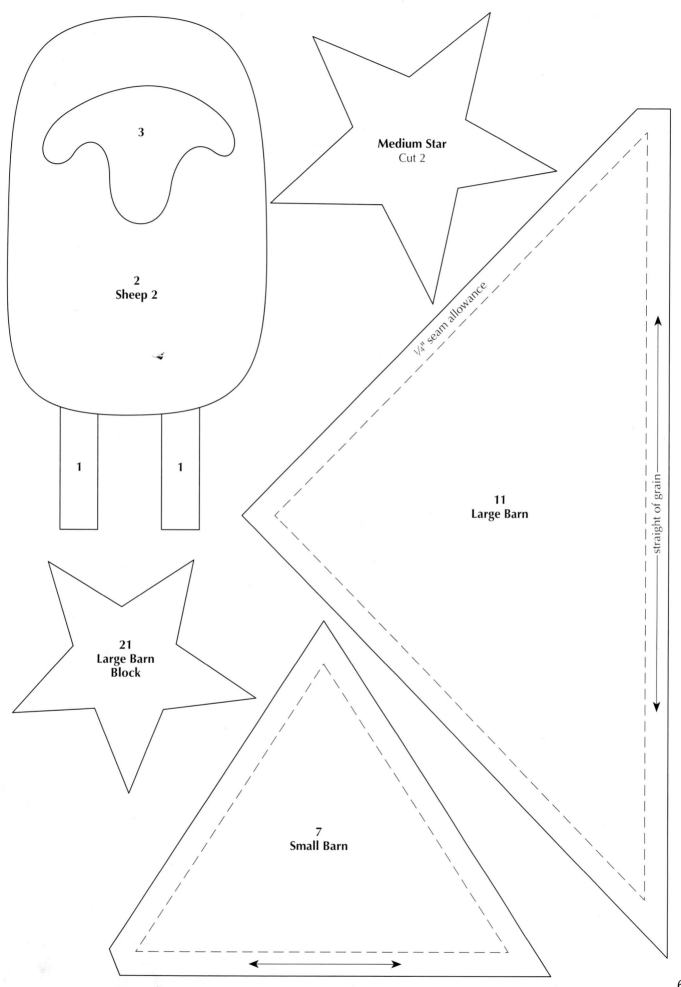

3

2
Sheep 2

1 1

Medium Star
Cut 2

¼" seam allowance

11
Large Barn

straight of grain

21
Large Barn
Block

7
Small Barn

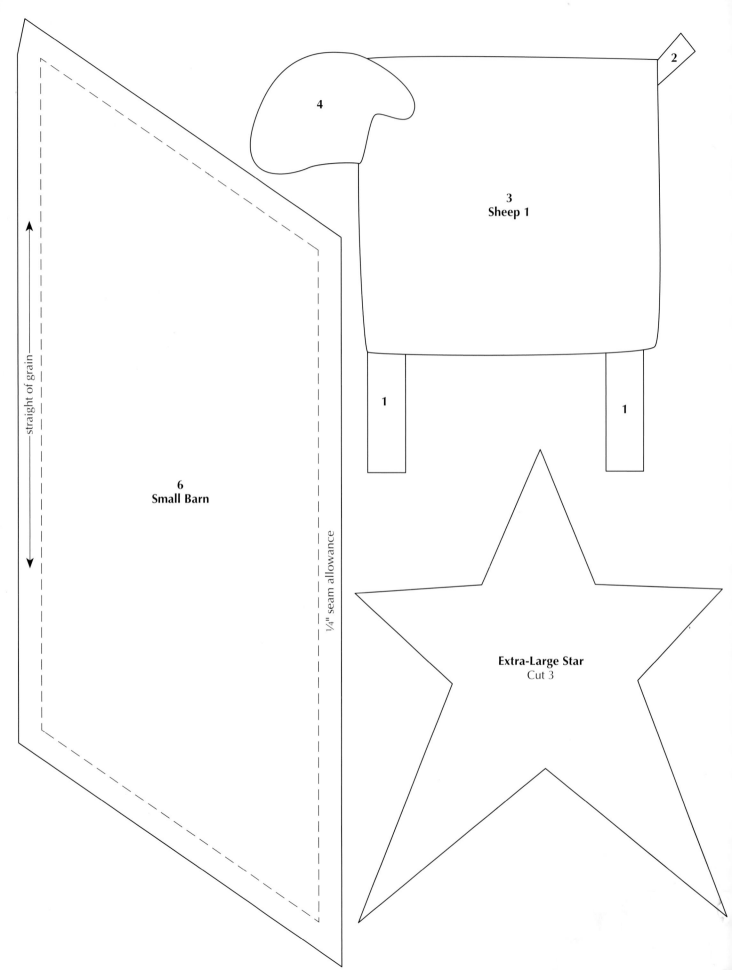

straight of grain

¼" seam allowance

**6
Small Barn**

4

2

**3
Sheep 1**

1

1

Extra-Large Star
Cut 3

The Garden

Quilt Size: 25½" x 33½"

RUA ALWAYS had the most beautiful garden in Hanlontown—and still does. She lives across the road from my parents' house, and I remember, while we were growing up, that she literally lived outdoors during the summer months. Her fingernails might have a bit of dirt under them, and her hair might be mussed from getting tangled in the raspberry patch, but she always wore a house dress while tending her prize tomatoes. She also spent an enormous amount of time with me and my sisters. We would stroll arm in arm through her yard, looking, touching, and smelling. In the end, she taught us all a thing or two about gardening.

My fondest memories of Rua are when my best friend, Ruth, and I would pile into the back of her old black car with Rua's dog, Puppy. We would drive to the woods on many a warm spring day and search the hills for wild flowers. Sometimes we'd even bring a few home to plant under the evergreen tree near Rua's house. Rua is now 96 and still the best gardener in town.

—Connie

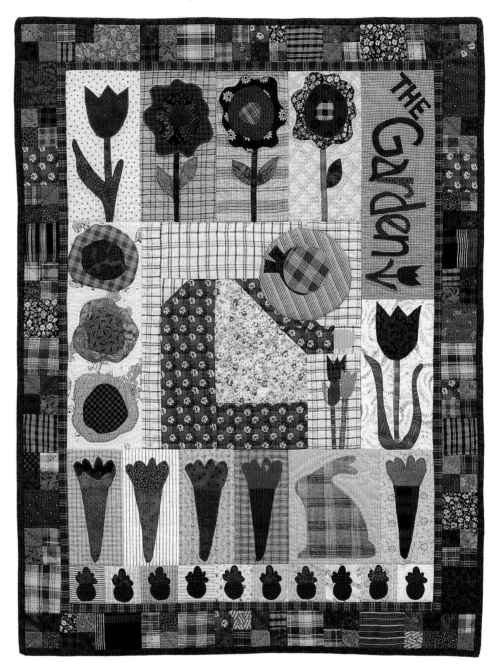

<h1 style="text-align:center">Materials: 44"-wide fabric</h1>

<div style="text-align:center">

1¼ yds. total of assorted lights
Scraps of assorted oranges and reds
⅛ yd. for inner border
¾ yd. total of assorted purples and greens
1 yd. for backing
¼ yd. for binding
Batting

</div>

Directions

All measurements include ¼"-wide seam allowances. Refer to pages 7–8 for sewing connector squares "c." Use the templates on pages 69–71. Refer to the individual block diagrams for positioning the appliqué pieces.

Grandma Block

Cut and piece 1 block, using pieces #1–#12. Appliqué pieces #13–#19.

Piece	Fabric	No. of Pieces	Dimensions
#1	Background	1	1½" x 12½"
#2	Background	1	3½" x 8½"
#3	Background	2	2" x 2"
#4	Background	1	3½" x 6"
#5	Background	1	3½" x 5½"
#6	Dress	1	3½" x 9½"
#7	Dress	1	Template #7
#8	Dress	1	1¼" x 1¼"
#9	Dress	2	2" x 2"
#10	Dress	1	3" x 5½"
#11	Apron	1	Template #11
#12	Apron	1	4½" x 5½"
#13	Hand	1	Template #13
#14	Hat brim	1	Template #14
#15	Hat ribbon	1	Template #15
#16	Hat crown	1	Template #16
#17	Tulip stems	2	Template #17
#18	Tulip flower	2	Template #18
#19	Tulip flower	1	Template #19

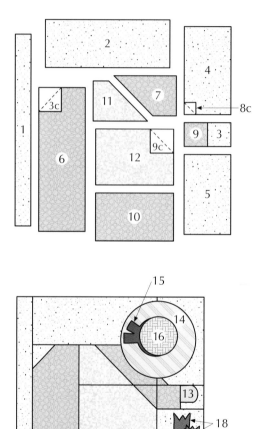

Grandma Block
Make 1.
Finished Size: 12" x 12"

Appliqué Blocks

1. From the assorted background fabrics, cut the following pieces.

Block	No. of Pieces	Dimensions	Appliqué Pieces
Cabbage	1	4½" x 12½"	3 each of #1 and #2
The Garden	1	4½" x 12½"	#1–#11
Carrot	5	3½" x 6½"	#1 and #2
Rabbit	1	5½" x 6½"	#1
Radish	10	2½" x 2½"	#1 and #2
Tulip 1	1	4½" x 8½"	#1–#3
Tulip 2	1	4½" x 8½"	#1–#3
Flower	3	4½" x 8½"	#1–#6

2. Appliqué the appropriate pieces onto each block.

Cabbage Block
Make 1.
Finished Size: 4" x 12"

The Garden Block
Make 1.
Finished Size: 4" x 12"

Carrot Block
Make 5.
Finished Size:
3" x 6"

Rabbit Block
Make 1.
Finished Size:
5" x 6"

Radish Block
Make 10.
Finished Size:
2" x 2"

Tulip 1 Block
Make 1.
Finished Size:
4" x 8"

Tulip 2 Block
Make 1.
Finished Size:
4" x 8"

Flower Block
Make 3.
Finished Size:
4" x 8"

Assembly and Finishing

1. Referring to the quilt plan on page 68 and the color photo on page 65, sew the blocks together.

2. From the inner border fabric, cut 2 strips, each 1" x 20½", for the top and bottom edges, and 2 strips, each 1" x 29½", for the sides. Sew the top and bottom inner borders to the quilt top first, then add the side borders.

3. For the outer border, cut the following pieces from the assorted purples and greens:
 - 8 rectangles, each 2½" x 3"
 - 16 squares, each 2½" x 2½"
 - 112 squares, each 1½" x 1½"

4. Join the 1½" squares into Four Patch blocks, then join the blocks with the squares and rectangles to make the pieced outer borders as shown.

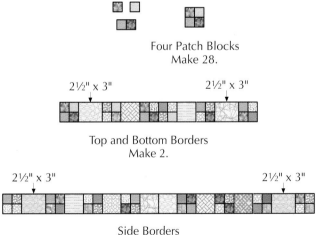

Four Patch Blocks
Make 28.

Top and Bottom Borders
Make 2.

Side Borders
Make 2.

5. Sew the top and bottom pieced borders to the quilt top, then add the side borders.

6. Layer the quilt top with batting and backing; baste. Quilt as desired and bind the edges.

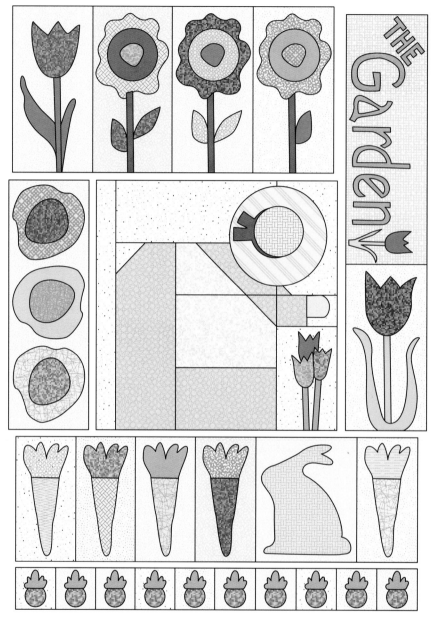

Quilt Plan

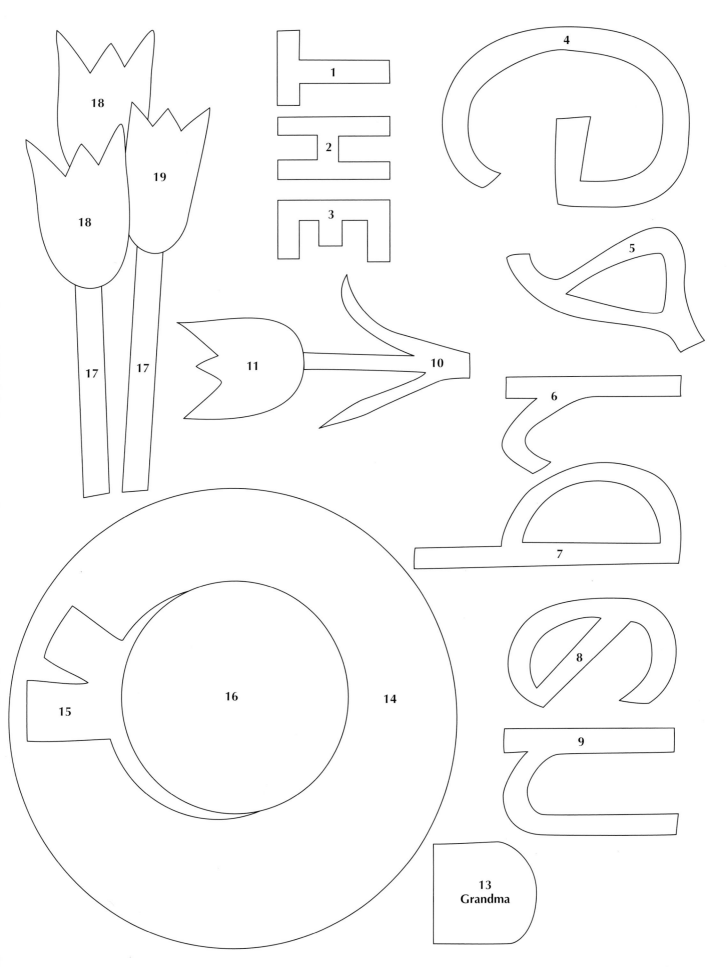

The numbers visible in the pattern pieces: 1, 2, 3, 4, 5, 6, 7, 8, 9, 10, 11, 13 Grandma, 14, 15, 16, 17, 17, 18, 18, 19

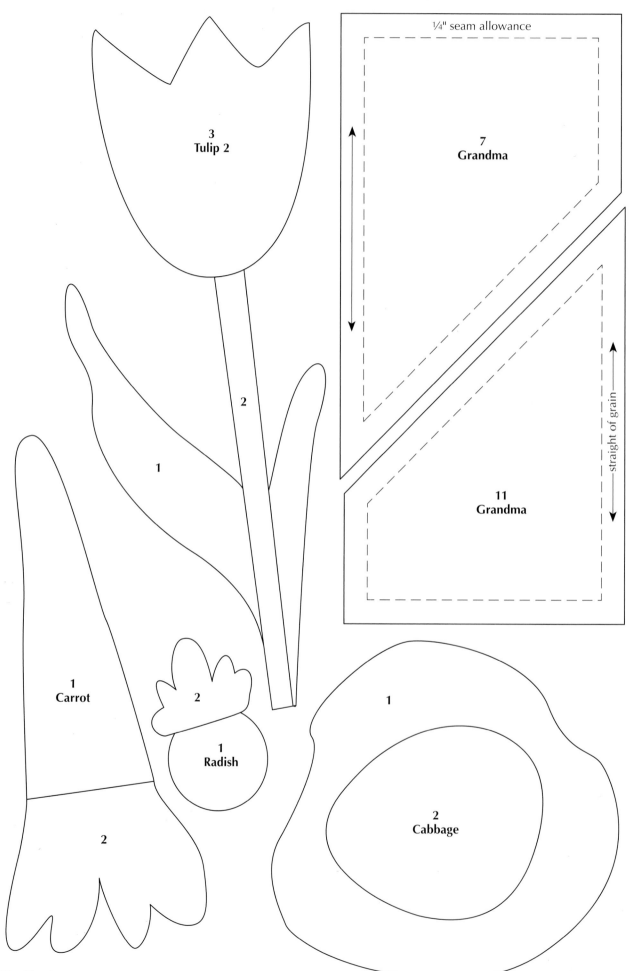

3
Tulip 2

¼" seam allowance

7
Grandma

2

straight of grain

11
Grandma

1

1
Carrot

2

1
Radish

1

2
Cabbage

2

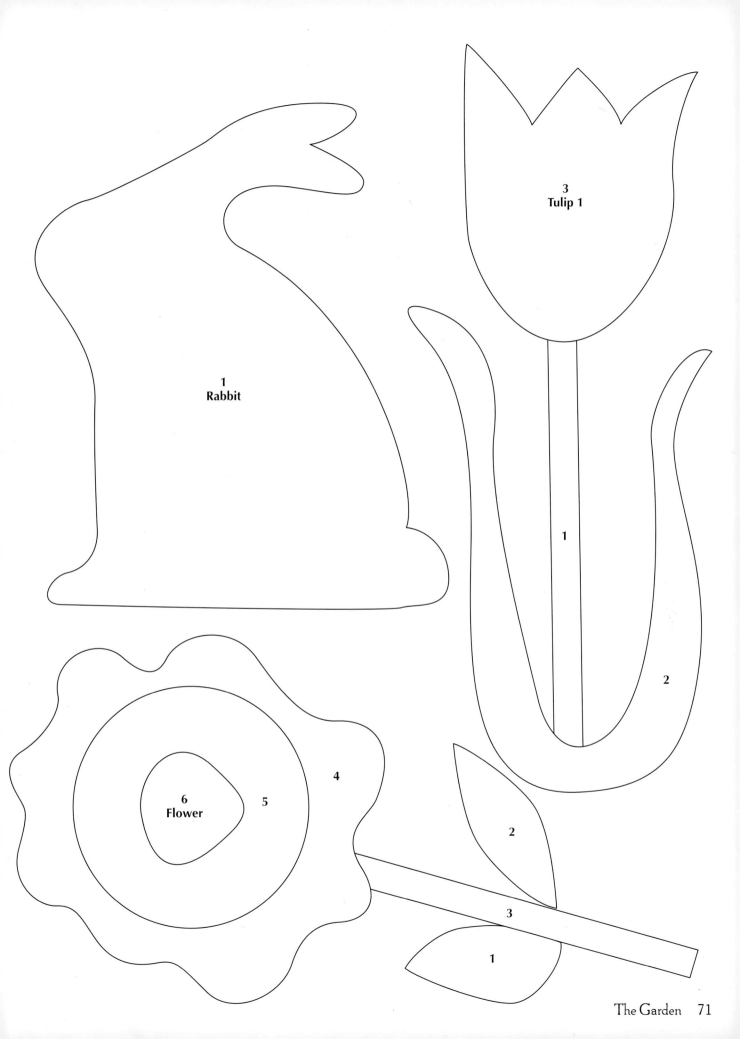

1
Rabbit

3
Tulip 1

1

2

6
Flower

5

4

2

3

1

Spools and Houses

Quilt Size: 29½" x 36½"

HOUSES are always popular at Country Threads, and we like to use houses of all shapes and sizes in our quilts. Earthy colors combined with simple, repeated shapes are not new ideas, but are a common thread in many traditional quilt projects.

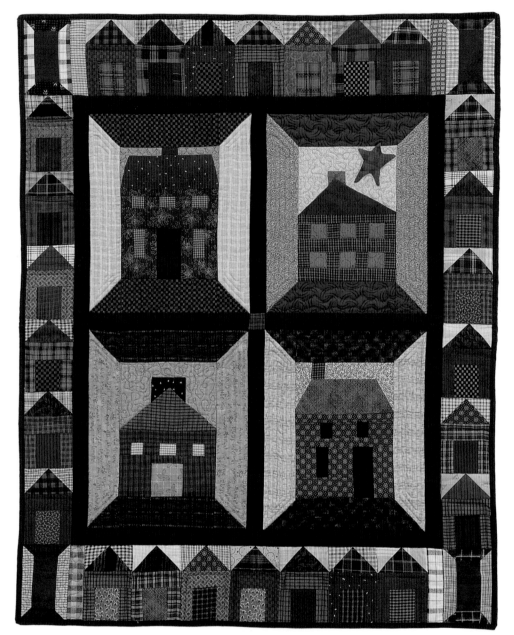

Materials: 44"-wide fabric

2¼ yds. total of assorted browns and dark reds
1 yd. total of assorted lights, golds, and greens
¼ yd. black for sashing and inner border
1 yd. for backing
¼ yd. for binding
Batting

Directions

All measurements include ¼"-wide seam allowances. The "r" next to a number means you flip the piece over and cut that number of reverse pieces. Refer to pages 7–8 for sewing connector squares "c." Use the templates on pages 76–77. Refer to individual block diagrams for positioning appliqué pieces.

House 1 Block

Cut and piece 1 block, using pieces #1–#17.

Piece	Fabric	No. of Pieces	Dimensions
#1	Dark	2	2½" x 6½"
#2	Dark (to match #1)	4	2½" x 2½"
#3	Medium	2	2½" x 12½"
#4	Background	2	1" x 3"
#5	Background	1 and 1r	Template #5
#6	Chimney	1	1" x 1½"
#7	Roof	1	Template #7
#8	House	1	1" x 6½"
#9	House	2	1¼" x 1¼"
#10	House	2	1¼" x 1½"
#11	House	1	1¾" x 6½"
#12	House	4	1¼" x 3½"
#13	House	2	1¼" x 1¾"
#14	Windows	2	1¼" x 1¼"
#15	Window	1	1¼" x 1½"
#16	Windows	2	1¼" x 2¼"
#17	Door	1	2" x 3½"

House 2 Block

Cut and piece 1 block, using pieces #1–#8. To add the roof, turn under ¼" along the short edges of piece #10 and pin to piece #4. Sew piece #5 to the bottom edge of pieces #4 and #10 as shown. Appliqué piece #9, then appliqué the top edges of piece #10. Appliqué the star (piece #11).

Piece	Fabric	No. of Pieces	Dimensions
#1	Dark	2	2½" x 6½"
#2	Dark (to match #1)	4	2½" x 2½"
#3	Medium	2	2½" x 12½"
#4	Background	1	4½" x 6½"
#5	House	1	1" x 6½"
#6	House	8	1¼" x 1½"
#7	House	2	1¼" x 6½"
#8	Windows	6	1½" x 1½"
#9	Chimney	1	1½" x 1½"
#10	Roof	1	Template #10
#11	Star	1	Template #11

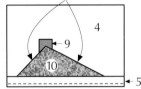

Turn under ¼".

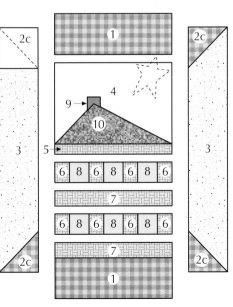

House 2 Block
Make 1.
Finished size: 10" x 12"

House 1 Block
Make 1.
Finished Size: 10" x 12"

House 3 Block

Cut and piece 1 block, using pieces #1–#12. To add the roof, turn under ¼" along the short edges of piece #14 and pin to piece #4. Sew piece #5 to the bottom edge of pieces #4 and #14 as shown. Appliqué piece #13, then appliqué the top edges of piece #14.

Piece	Fabric	No. of Pieces	Dimensions
#1	Dark	2	2½" x 6½"
#2	Dark (to match #1)	4	2½" x 2½"
#3	Medium	2	2½" x 12½"
#4	Background	1	4½" x 6½"
#5	House	1	1¼" x 6½"
#6	House	2	1¼" x 1¼"
#7	House	2	1¼" x 1½"
#8	House	1	1" x 2½"
#9	House	2	2½" x 3"
#10	Windows	2	1¼" x 1¼"
#11	Window	1	1¼" x 1½"
#12	Door	1	2½" x 2½"
#13	Chimney	1	1¾" x 2½"
#14	Roof	1	Template #14

House 4 Block

Cut and piece 1 block, using pieces #1–#17.

Piece	Fabric	No. of Pieces	Dimensions
#1	Dark	2	2½" x 6½"
#2	Dark (to match #1)	4	2½" x 2½"
#3	Medium	2	2½" x 12½"
#4	Background	1	1½" x 1½"
#5	Background	1	1½" x 4¾"
#6	Background	1 and 1r	Template #6
#7	Chimney	1	1¼" x 1½"
#8	Roof	1	Template #8
#9	House	2	1" x 6½"
#10	House	3	1½" x 2"
#11	House	1	2" x 2¼"
#12	House	1	1¾" x 2¼"
#13	House	1	1¾" x 4"
#14	House	1	1¾" x 3½"
#15	Windows	2	1¼" x 1½"
#16	Window	1	1¼" x 2¼"
#17	Door	1	1¾" x 3½"

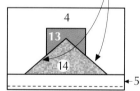

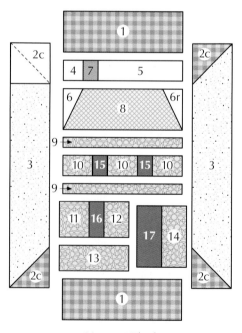

House 4 Block
Make 1.
Finished Size: 10" x 12"

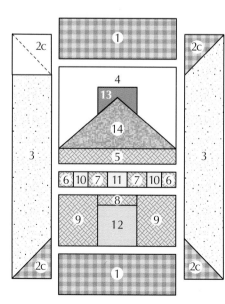

House 3 Block
Make 1.
Finished Size: 10" x 12"

Small House Blocks

Cut and piece 26 blocks, using pieces #1–#5. Cutting directions are for 1 block.

Piece	Fabric	No. of Pieces	Dimensions
#1	Background	2	2" x 2"
#2	Roof	1	2" x 3½"
#3	House	1	1½" x 3½"
#4	House	2	1¼" x 2½"
#5	Door	1	2" x 2½"

Small House Block
Make 26.
Finished Size: 3" x 4½"

Spool Blocks

Cut and piece 4 blocks, using pieces #1–#4. Cutting directions are for 1 block.

Piece	Fabric	No. of Pieces	Dimensions
#1	Medium	1	2" x 3½"
#2	Dark	2	1¼" x 2"
#3	Dark (to match #2)	4	1¼" x 1¼"
#4	Light	2	1¼" x 5"

Spool Block
Make 4.
Finished Size: 3" x 4½"

Assembly and Finishing

1. From the black fabric, cut:
 2 strips, each 1½" x 10½", for horizontal sashing
 2 strips, each 1½" x 12½", for vertical sashing
 2 strips, each 1½" x 21½", for top and bottom borders
 2 strips, each 1½" x 27½", for side borders

2. From a dark fabric, cut 1 square, 1½" x 1½".

3. Referring to the quilt plan on page 76 and the color photo on page 72, join House blocks 1–4 with vertical sashing strips between blocks 1 and 2 and between blocks 3 and 4. Join the horizontal sashing strips and 1½" square. Sew this between the 2 rows of House blocks.

4. Sew the top and bottom inner borders to the quilt top first, then add the side borders.

5. For the pieced side borders, make 2 vertical rows, each with 6 Small House blocks. Sew the borders to the side edges of the quilt top.

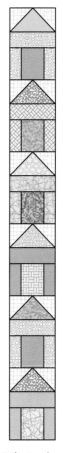

Side Borders
Make 2.

6. For the pieced top and bottom borders, make 2 horizontal rows, each with 7 Small House blocks. Cut 4 strips, each 1½" x 5", from the assorted background fabrics. Add 1 strip and 1 Spool block to each end of the rows. Sew the borders to the top and bottom edges of the quilt top.

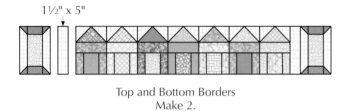

1½" x 5"

Top and Bottom Borders
Make 2.

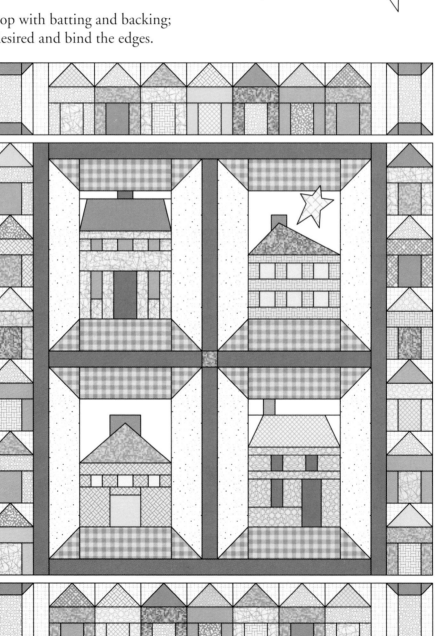

11
House 2

7. Layer the quilt top with batting and backing; baste. Quilt as desired and bind the edges.

Quilt Plan

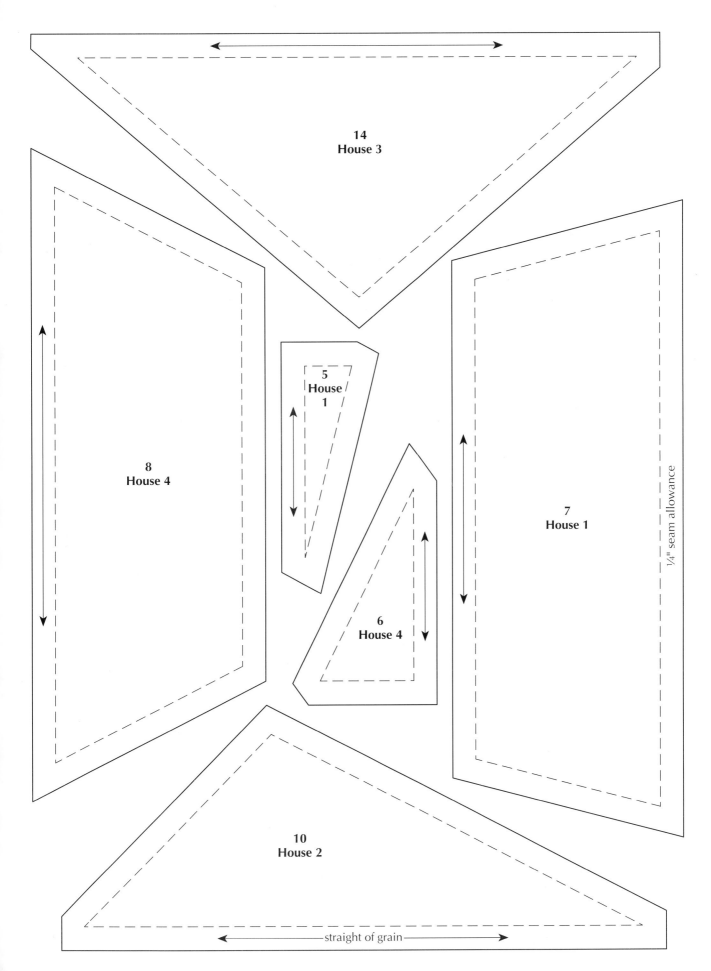

14
House 3

8
House 4

5
House
1

7
House 1

¼" seam allowance

6
House 4

10
House 2

straight of grain

Rabbit Hollow

Quilt Size: 72½" x 102½"

"RABBIT HOLLOW" was designed as a companion to the "Rabbit Run" quilt in our first book for That Patchwork Place, *Country Threads*. We like rabbits, vegetables, and flowers, and usually include one or more of them in our quilts. The majority of the pieces in this quilt were hand appliquéd because they are large enough for our worn fingers and weak eyes to handle. But we did resort to fusible appliqué for the letters and flower stems.

The checkerboards scattered around the quilt top add a bit of variety between the large background blocks. Even if we did use different colors than we normally do, the Country flavor still comes shining through.

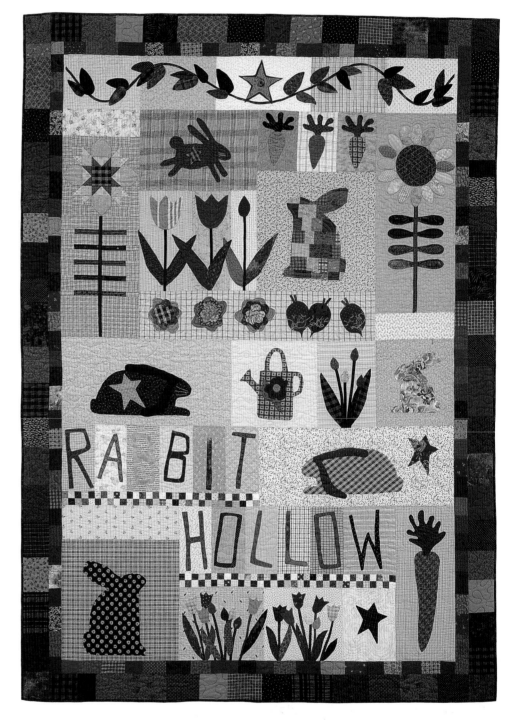

Materials: 44"-wide fabric

3 yds. total of assorted light background fabrics
1½ yds. total of assorted greens
¾ yd. total of assorted reds, pinks, roses, maroons, and oranges
¾ yd. total of assorted golds, blues, teals, purples, rusts, and black
6 yds. for backing
½ yd. for binding
Batting
1 button for top banner

Directions

All measurements include ¼"-wide seam allowances. The "r" next to a number means you flip the piece over and cut that number of reverse pieces. Refer to pages 7–8 for sewing connector squares "c." Use the templates on pages 84–92 and on the pull-out pattern. Refer to the individual block diagrams for positioning the appliqué pieces.

Pieced Sunflower Block

1. Cut and piece 1 flower stem, using pieces #1–#6.

Piece	Fabric	No. of Pieces	Dimensions
#1	Background	1	2½" x 12½"
#2	Background	10	1¼" x 2½"
#3	Background	4	2" x 12½"
#4	Background	1	6¾" x 12½"
#5	Leaves	5	1¼" x 8½"
#6	Stem	1	1" x 18½" (½" x 18½" if fusing)

2. Cut and piece 1 flower head, using pieces #1–#11.

Piece	Fabric	No. of Pieces	Dimensions
#1	Brown	1	3½" x 3½"
#2	Brown	4	2⅜" x 2⅜" ◻
#3	Gold	1	4¼" x 4¼" ⊠
#4	Gold	4	2" x 2"
#5	Gold	4	2⅜" x 2⅜" ◻
#6	Gold	4	3½" x 3½"
#7	Background	8	2" x 2"
#8	Background	4	2⅜" x 2⅜" ◻
#9	Background	4	2" x 2"
#10	Background	4	2" x 3½"
#11	Background	4	2" x 5"

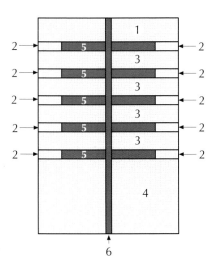

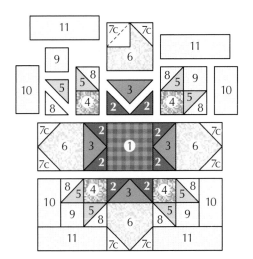

3. Join the flower head and stem to make 1 pieced Sunflower block.

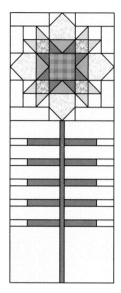

Pieced Sunflower Block
Make 1.
Finished Size: 12" x 30"

Top Banner

1. From the assorted light background fabrics, cut 4 rectangles, each 8½" x 12", and 1 rectangle, 8½" x 14½". Join the rectangles end to end, placing the 14½"-wide rectangle in the middle.
2. Appliqué pieces #1–#5. For the stem, cut bias strips, each ¾" wide, and join them to make one continuous piece approximately 70" long. Add a button to the middle of the star.

Appliqué Blocks

1. From the assorted light background fabrics, cut 1 each of the following pieces, except for the small carrot—cut 3 pieces.

Block	Dimensions	Appliqué Pieces
Rabbit 1	12½" x 18½"	#1 and #2
Rabbit 2	12½" x 13½"	#1
Rabbit 3	13½" x 26½"	#1–#3
Rabbit 4	12½" x 30½"	#1r–#3r
Rabbit 5	18½" x 18½"	#1
Sunflower	12½" x 30½"	#1–#4
	(Cut 1" x 20" strip of green for piece #2*.)	
Large Carrot	9½" x 23½"	#1 and #2
Small Carrot	6½" x 9½" (cut 3)	#1 and #2
Cabbage and Beets	7½" x 36½"	#1–#5
Watering Can	13½" x 13½"	#1–#4
Star	8½" x 11½"	#1

*Cut strip ½" x 20" if fusing.

2. Appliqué the appropriate pieces onto each block.

Rabbit 1 Block
Make 1.
Finished Size: 18" x 12"

Rabbit 2 Block
Make 1.
Finished Size: 12" x 13"

Rabbit 3 Block
Make 1.
Finished Size: 26" x 13"

Top Banner
Make 1.
Finished Size: 60" x 8"

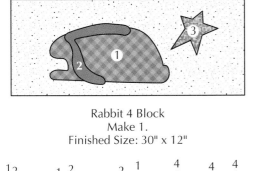

Rabbit 4 Block
Make 1.
Finished Size: 30" x 12"

Cabbage and Beets Block
Make 1.
Finished Size: 36" x 7"

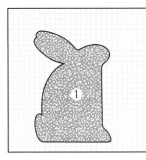

Rabbit 5 Block
Make 1.
Finished Size: 18" x 18"

Sunflower Block
Make 1.
Finished Size: 12" x 30"

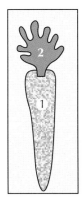

Large Carrot Block
Make 1.
Finished Size: 9" x 23"

Star Block
Make 1.
Finished Size: 8" x 11"

Watering Can Block
Make 1.
Finished Size: 13" x 13"

Small Carrot Block
Make 3.
Finished Size: 6" x 9"

Tulip Blocks

1. From the assorted light background fabrics, cut 1 each of the following pieces.

Block	Dimensions	Appliqué Pieces	Stems*
Tulip 1	8½" x 15½"	#1 and #3	Cut 1 (¾" x 11")
Tulip 2	6½" x 15½"	#1–#3	Cut 1 (¾" x 11")
Tulip 3	4½" x 15½"	#1, #2, and #4	Cut 1 (¾" x 11")
Tulip 4	9½" x 13½"	#1 and #2	Cut 4 (¾" x 5" to 9")
Tulip 5	11½" x 13½"	#1–#4	Cut 8 (¾" x 5" to 9")
Tulip 6	11½" x 12½"	#1–#4	Cut 7 (¾" x 5" to 9")

Cut stems ¼" wide if fusing.

2. Appliqué the appropriate pieces onto each block. For hand-appliquéd stems, fold each long edge under ¼" to make finished stems ¼" wide; appliqué in place. Or, fuse the ¼"-wide stems.

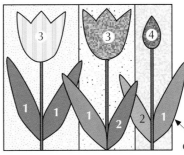

Add last leaf when quilt top is assembled.

Tulips 1, 2, and 3 Blocks
Join to make 1 large block.
Finished Size: 18" x 15"

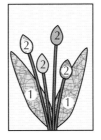

Tulip 4 Block
Make 1.
Finished Size: 9" x 13"

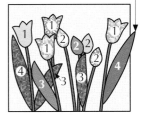

Tulip 5 Block
Make 1.
Finished Size: 13" x 11"

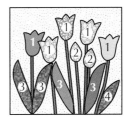

Tulip 6 Block
Make 1.
Finished Size: 12" x 11"

Pieced Rabbit Block

1. From a light background fabric, cut 1 square, 18½" x 18½".
2. From the assorted fabrics, cut a variety of strips, each 2½" wide. Crosscut the strips into segments from 2" to 4" long.
3. Join the segments in rows, then join the rows to make 1 piece of fabric, approximately 11" x 15". Using the Rabbit 5 template (reversed), cut the appliqué piece from the pieced fabric; appliqué to the background square.

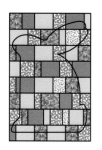

Approximately 11" x 15"

Pieced Rabbit Block
Make 1.
Finished Size: 18" x 18"

Alphabet Blocks

1. From the assorted light background fabrics, cut 6 rectangles, each 5½" x 10½". Cut out and appliqué the letters "R A B B I T." Join the blocks in a horizontal row.

Rabbit
Make 1 each letter.
Finished Size: 30" x 10"

2. From the assorted light background fabrics, cut 5 rectangles, each 5½" x 10½", and 1 rectangle,

8½" x 10½". Cut out and appliqué the letters "H O L L O W" placing the "W" on the 8½"-wide rectangle. Join the blocks in a horizontal row.

Hollow
Make 1 each letter.
Finished Size: 33" x 10"

Checkerboards

From the assorted red and light scraps, cut 63 red squares and 63 light squares, each 1½" x 1½". Join the red and light squares in pairs. Join 30 pairs to make 1 row. Join 33 pairs to make a second row.

Join 30 pairs.
Make 1.

Join 33 pairs.
Make 1.

Assembly and Finishing

1. From the assorted light background fabrics, cut the following spacer pieces.

No. of Pieces	Dimensions
2	12½" x 4½"
1	18½" x 5½"

2. Referring to the quilt plan on page 83 and the color photo on page 78, sew all the blocks and spacer pieces together.

3. The inner border is a "chunk" border, made up of 2½"-wide squares and rectangles. From the assorted red fabrics, cut a variety of strips, each 2½" wide, then crosscut into random lengths. Join the pieces to make the top and bottom borders, each 60½" long, and 2 side borders, each 94½" long. Sew the top and bottom inner borders to the quilt top first, then add the side borders.

4. From the assorted green and blue fabrics, cut a variety of strips, each 4½" wide, then crosscut into random lengths for the outer chunk border. Join the pieces to make the top and bottom

borders, each 64½" long, and 2 side borders, each 102½" long. Sew the top and bottom outer borders to the quilt top; add the side borders.

Inner Border

Outer Border

5. Layer the quilt top with batting and backing; baste. Quilt as desired and bind the edges.

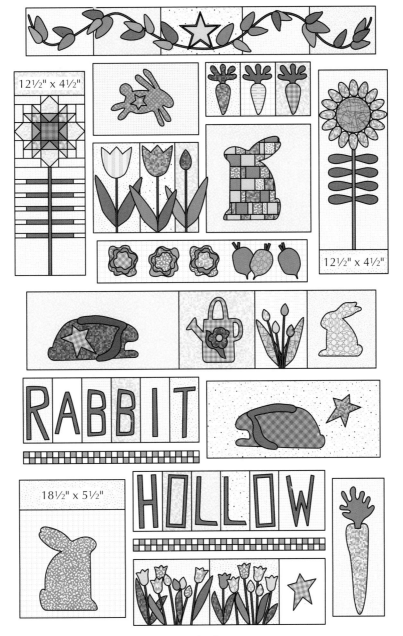

Quilt Plan

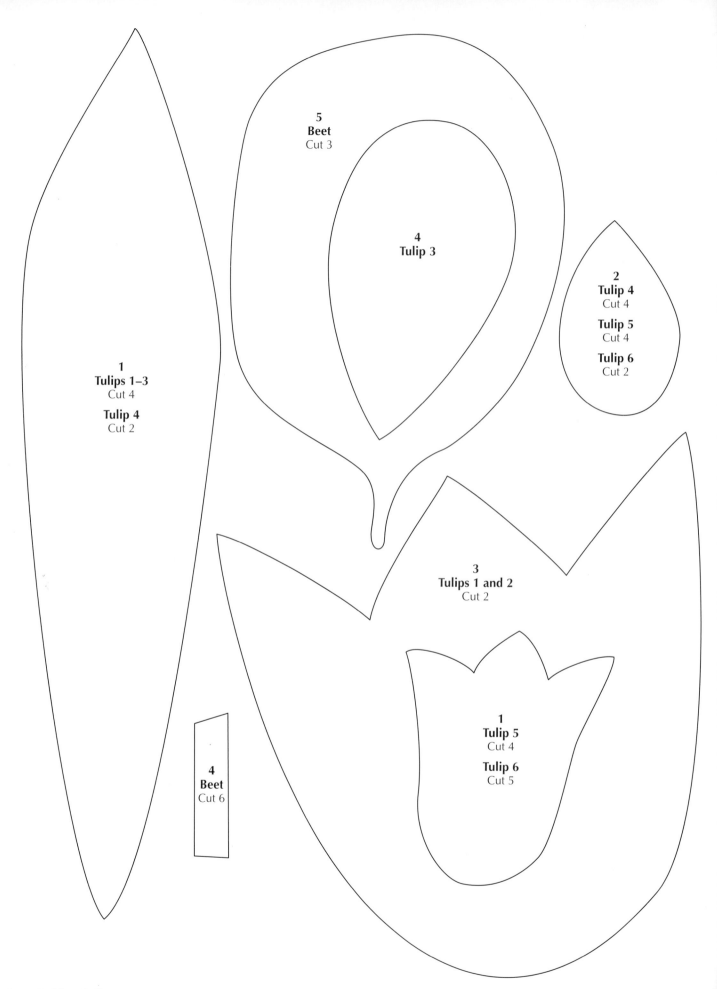

5
Beet
Cut 3

4
Tulip 3

2
Tulip 4
Cut 4

Tulip 5
Cut 4

Tulip 6
Cut 2

1
Tulips 1–3
Cut 4

Tulip 4
Cut 2

3
Tulips 1 and 2
Cut 2

1
Tulip 5
Cut 4

Tulip 6
Cut 5

4
Beet
Cut 6

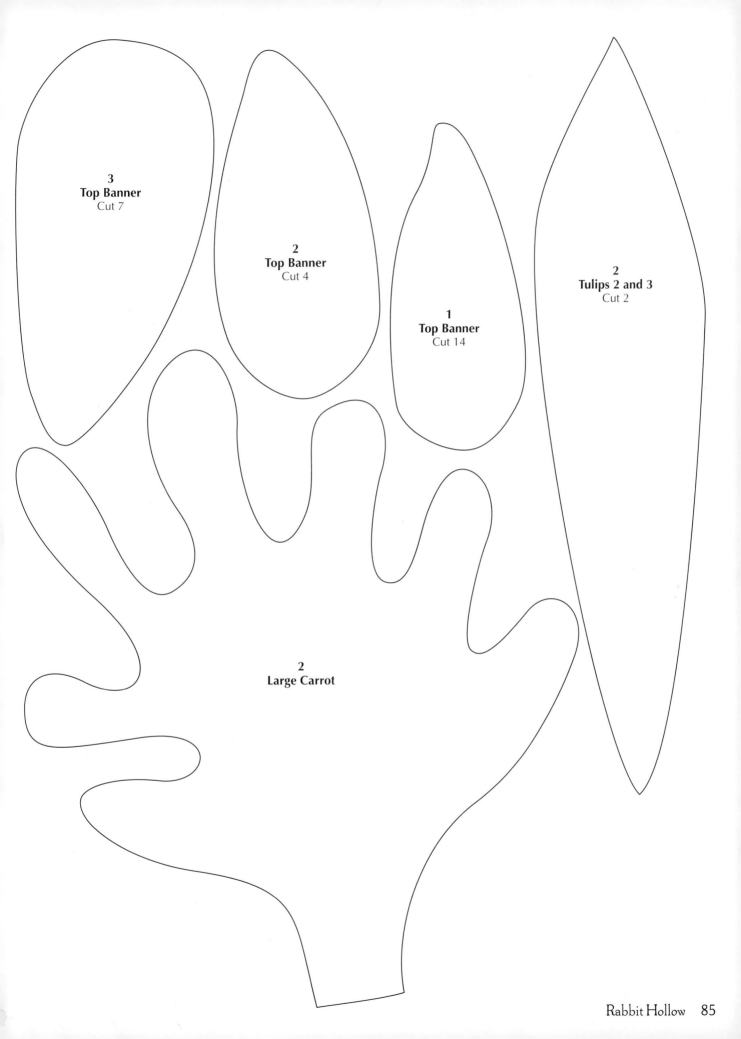

3
Top Banner
Cut 7

2
Top Banner
Cut 4

1
Top Banner
Cut 14

2
Tulips 2 and 3
Cut 2

2
Large Carrot

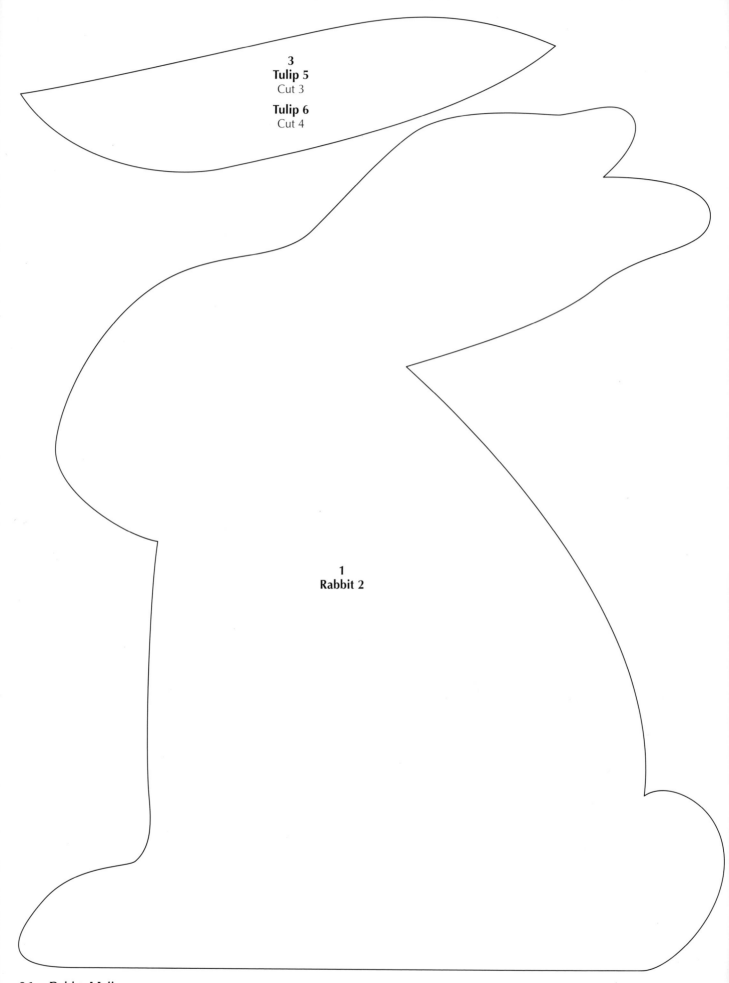

3
Tulip 5
Cut 3

Tulip 6
Cut 4

1
Rabbit 2

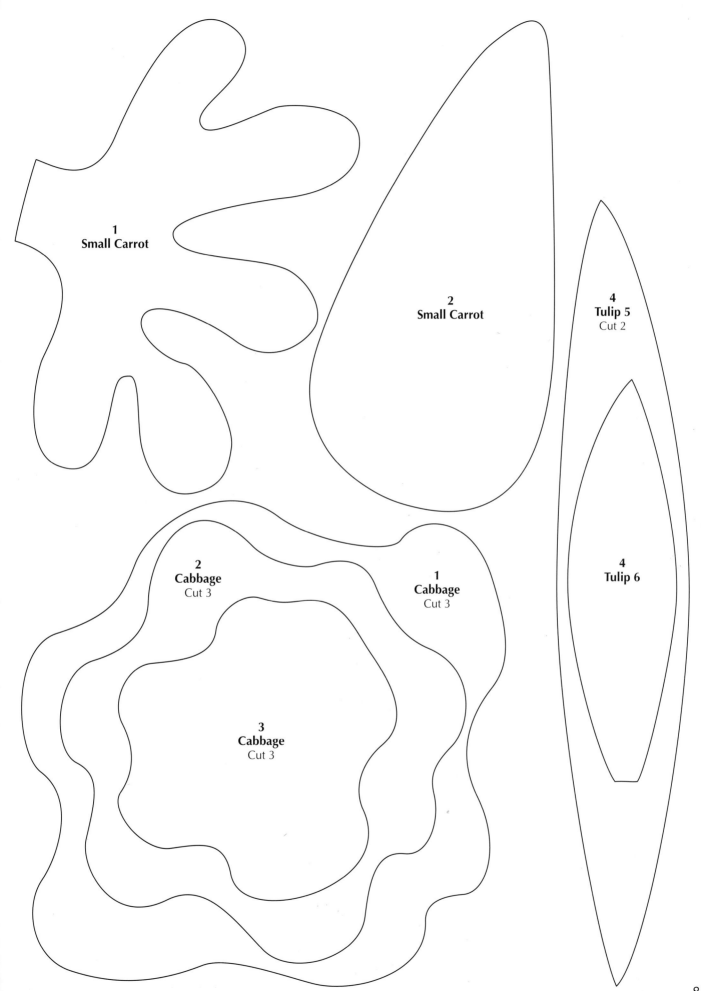

1
Small Carrot

2
Small Carrot

4
Tulip 5
Cut 2

4
Tulip 6

2
Cabbage
Cut 3

1
Cabbage
Cut 3

3
Cabbage
Cut 3

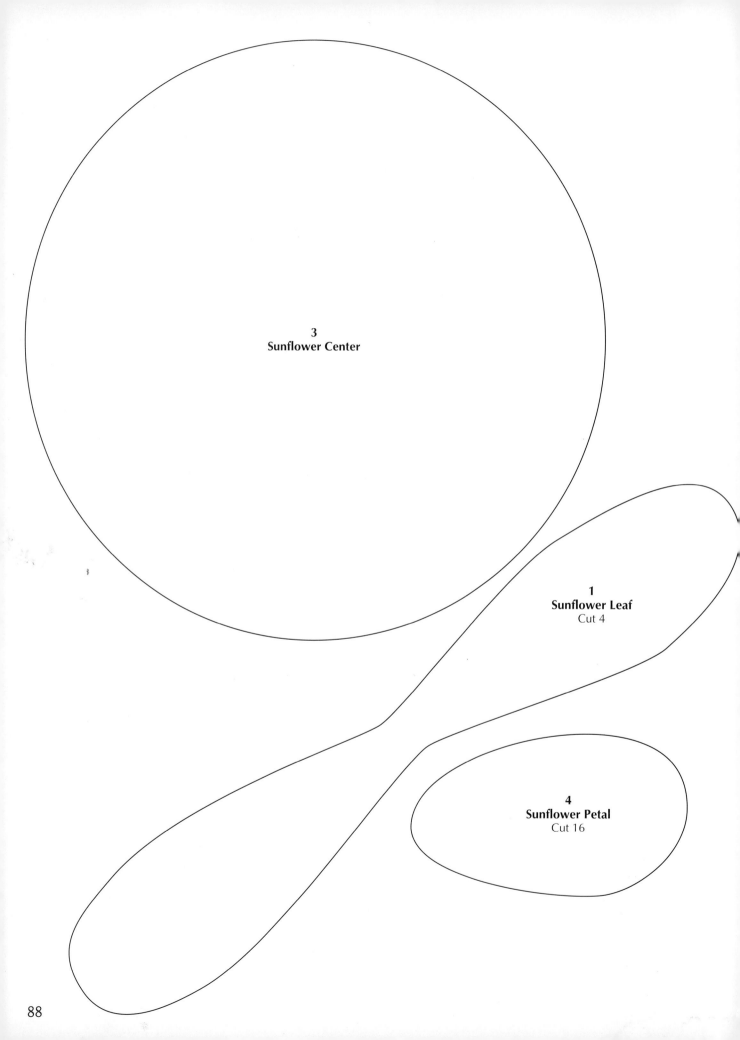

3
Sunflower Center

1
Sunflower Leaf
Cut 4

4
Sunflower Petal
Cut 16

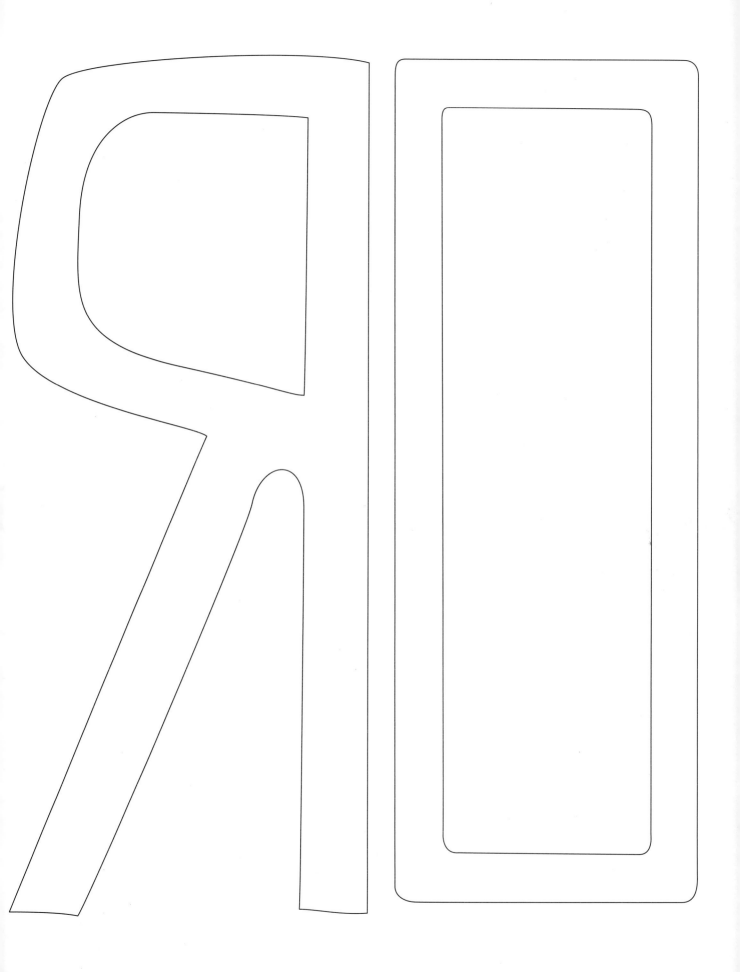

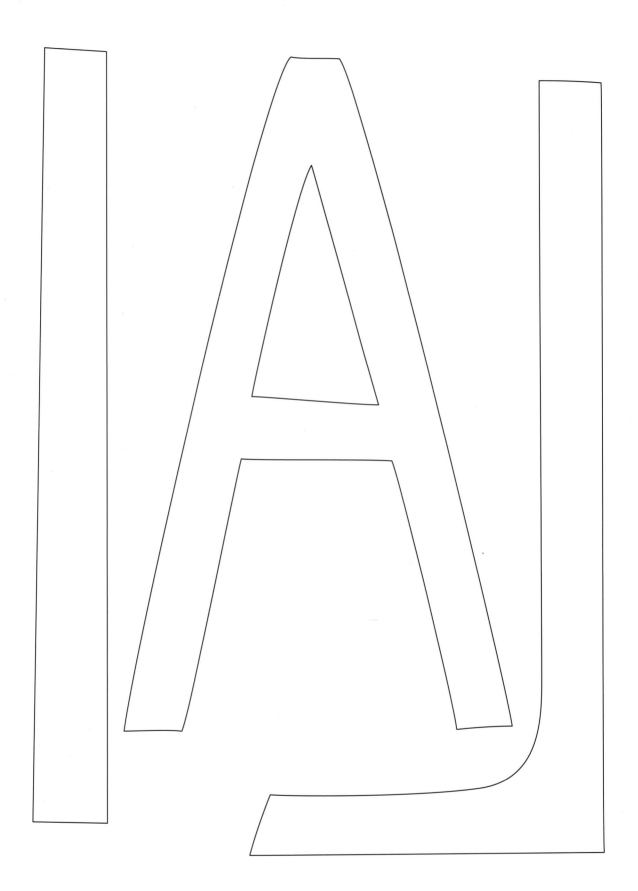

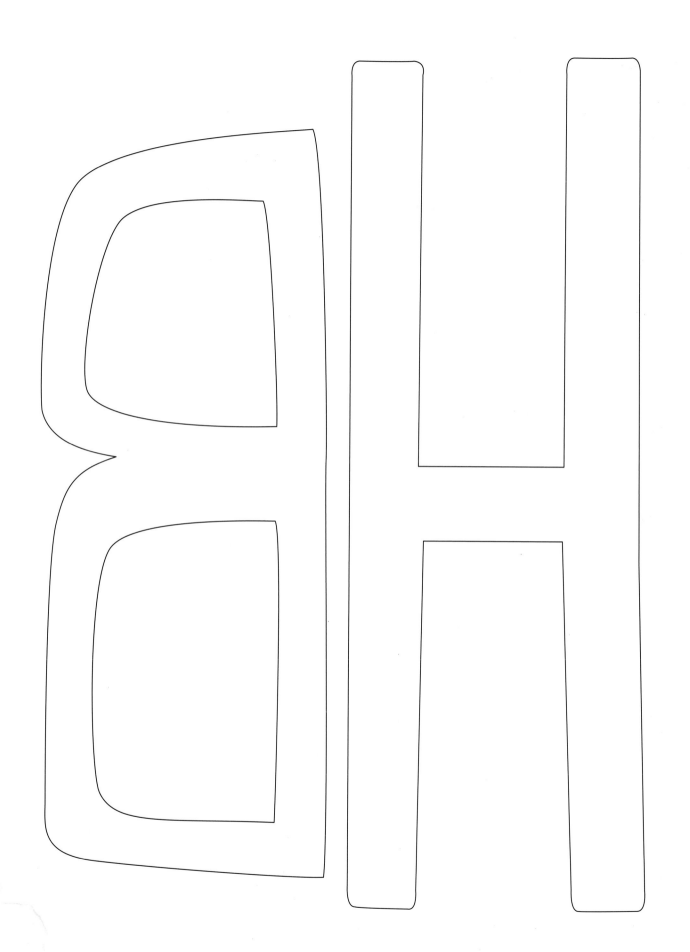

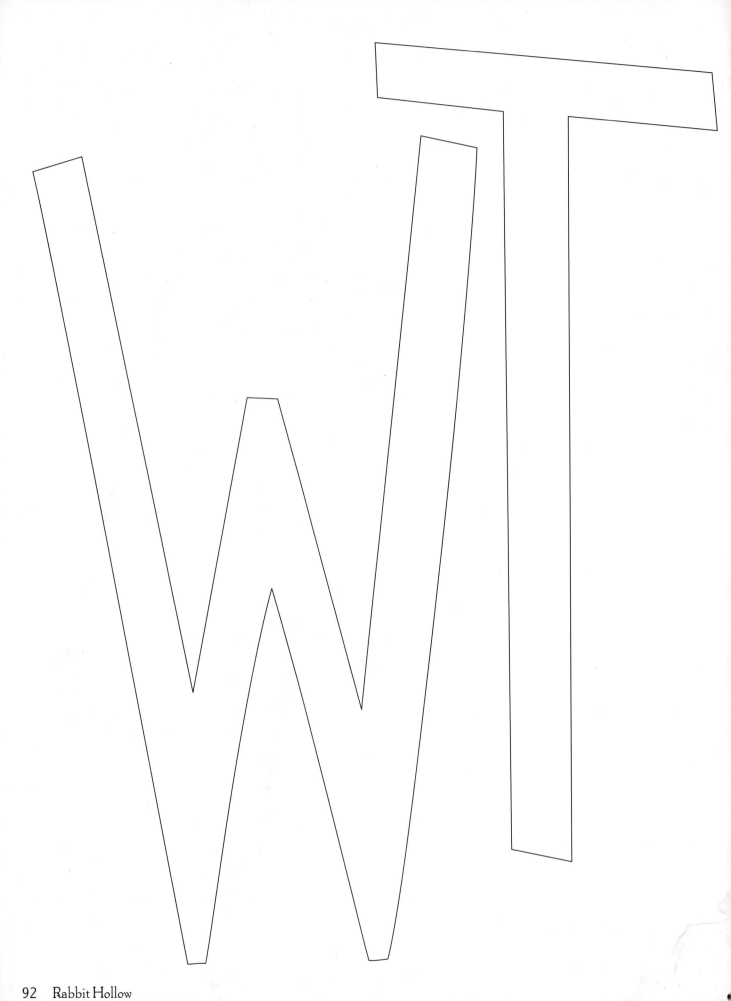